Caravaggio's Secrets

OCTOBER BOOKS

Caravaggio's Secrets

Leo Bersani and Ulysse Dutoit

An OCTOBER Book

The MIT Press
Cambridge, Massachusetts
London, England

This book was set in Bembo by Graphic Composition, Inc. and was printed and bound in the United States of America.

Library of Congress Cataloging-in-Publication Data

Bersani, Leo.
 Caravaggio's secrets / Leo Bersani and Ulysse Dutoit.
 p. cm.
 "An October book."
 Includes bibliographical references and index.
 ISBN 0-262-02449-7 (hc : alk. paper)
 1. Caravaggio, Michelangelo Merisi da, 1573–1610—Psychology.
 I. Dutoit, Ulysse, 1944– . II. Title.
 ND623.C26B48 1998
 759.5—dc21
 98-17336
 CIP

For Andrée Schlemmer

Contents

Contents

ILLUSTRATIONS

The color plates follow page 60.

Caravaggio's Secrets

1

SEXY SECRETS

On at least two occasions in his work, Caravaggio offers us his head. In a particularly lurid version of self-oblation, Caravaggio painted his own features on the bloody head of Goliath being held by the hair at arm's length by a victorious David and thrust toward the viewer, in the Galleria Borghese representation of that Biblical episode. To judge from several other paintings, Caravaggio seems to have found in decapitation a nearly irresistible aesthetic appeal. Not only have two other versions of David with Goliath's head been attributed to Caravaggio; there are also Judith in the very act of cleaving through Holofernes' head with the latter's sword; St. John's partially severed head in the Malta *Decapitation of St. John the Baptist;* the same luckless saint's head being dropped onto a platter held by Salome in the London version of *Salome Receiving the Head of St. John the Baptist* (a third version of this episode, now in Madrid, has also been attributed to Caravaggio); and, finally, the Medusa head, mouth agape and eyes opened wide in terror, originally painted on a parade shield held in the hand of a lifesize equestrian sculpted figure in the Medici armory, and now itself removed from that original body and on view at the Uffizi in Florence. But in the other self-portrait we have in mind—the early *Bacchino Malato*—the painter's head rests firmly enough on a provocatively curved shoulder, and what we are being offered in that head, what is directed toward us, could be read as an erotically soliciting gaze.

We want to propose a certain interpretive itinerary from this gaze of the Bacchus self-portrait to the decapitated Goliath/Caravaggio. Let's begin by attacking head-on, so to speak, the trap set for us by images of decapitation. The psychoanalytic association of decapitation with castration has become an interpretive reflex; many people are inclined to take that connection for granted without ever having been instructed to do so by Freud's short piece on the Medusa head. And yet, while we will be acknowledging the irresistible nature of that interpretation—irresistible in large part because Caravaggio himself appears to be proposing it pictorially—we will also be arguing for the need to interpret castration. Far from being the final term in a reading of Caravaggio's images of decapitation, castration is "illuminated" by decapitation, by a cutting off of that part of the body where interpretation itself originates, without which we would never see decapitation as castration. Without *our* heads, we would not be speculating about what the heads in Caravaggio's paintings may "mean," and one way to make us lose our heads—to ruin any confidence we might have about "knowing" him, or, as we shall see, about the very possibility of knowledge—is for Caravaggio to decapitate himself, to thrust toward us (as David thrusts Goliath's head toward the spectator) a bodyless head that can no longer say or mean anything, that can no longer be read.

If Caravaggio finally adopts that extreme solution to what he seems to have anticipated as centuries of interpretive promiscuity in front of his work, he began by seductively inviting the spectator to read him. His paintings repeatedly initiate the conditions under which a visual field more or less urgently solicits and resists its own symbolization. Caravaggio frequently paints the act of looking—a looking at times directed outside the painting, toward the spectator, and at other times situated among the figures within the represented scene. Among the former, much attention has been given to those in which a boy appears to be looking more or less provocatively toward the spectator. We are thinking of the *Boy with a Basket of Fruit*, the *Bacchino Malato* (both from the mid-1590s and both in the Borghese Gallery in Rome), the Uffizi *Bacchus* from a few years later, and the Berlin *Victorious Cupid* (c. 1601–02). The poses and the looks in these paintings have generally been recognized as erotically provocative, an accurate

enough description if we mean by that a body in which we read an intention to stimulate our desire, not only to contemplate the body but to approach it, to touch it, to enter into or to imagine some form of intimate physical contact with it. What has been called a perplexing, even indecorous nudity (Cupid's position, for example, exposes not only his genitals but also the cleavage of his buttocks), bared shoulders, enticing smiles or half-smiles, sensuous parted lips: given all this, and in spite of important variations among the works just mentioned, it seems plausible to say that Caravaggio has painted a series of sexual come-ons.

The come-ons are, however, somewhat ambiguous. In two of the paintings, the *Bacchino Malato* and the *Boy with a Basket of Fruit*, the erotic invitation is qualified by a partially self-concealing movement of retreat. The Bacchus self-portrait (c. 1593; fig. 1.1)[1] is at once exhibitionist and self-concealing: if the shoulder is enticingly curved, the movement of the entire arm closes in on the body, which it could be understood as thereby concealing or protecting from the very advances it simultaneously invites. Also, the greenish hue of the flesh (which accounts for the designation of the *bacchino* as "malato") adds a repellent and repelling note to the provocation. The provocation and the withdrawal are, however, quite evidently poses, which should make us hesitate to see either the self-exposure *or* the self-concealment as natural, or as psychologically significant. The curious inclusion of a section of the youth's spread legs invites us to reconstruct the moment before he turned his head to the right and positioned his arm to raise the bunch of grapes to his lips. (Since this is a self-portrait, we might imagine the painter, sitting in front of his canvas, not yet having turned toward the mirror in which he will see himself as he will paint himself, posing as Bacchus.) There is something grossly natural about those thematically irrelevant knees; they emphasize, by contrast, the youth's role-playing with the rest of his body. Thus, there is already, even in this very early painting, an ironic comment on the double movement we will qualify as erotic: the soliciting move toward the viewer, and the self-concealing move away from the viewer. It is, we will argue, the movement away that fascinates, indeed that eroticizes the body's apparent (and deceptive) availability. The latter is at once put into question and sexualized by the suggestion of a secret, although the exaggerated artfulness of

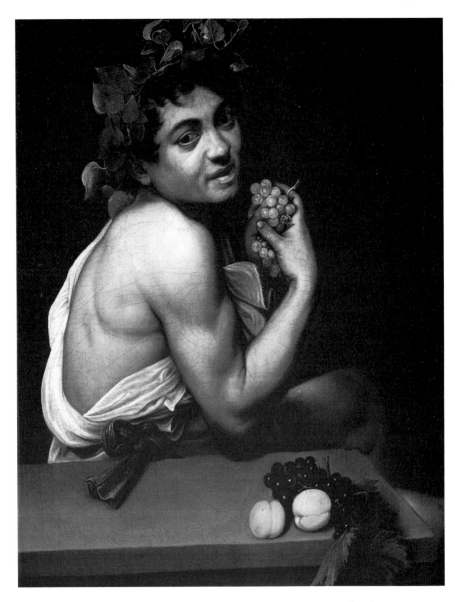

1.1 *Bacchino Malato* ("Sick Bacchus"), c. 1593. Rome, Galleria Borghese. (Also plate 1.)

the entire operation in the *Bacchino Malato* makes of that very suggestion only one element in a nonerotic process of aesthetic design. It is as if this remarkable work included a warning about the reading it also crudely solicits and frustrates.

Furthermore, not only may the whole thing be nothing but a pose; the very setting that supports the pose also works against its erotically provocative nature. What is this half-naked youth inviting us to see? His genitals (unlike those of Cupid) are hidden, and yet they are also visible. More exactly, they are repeated as something else: both as the knotted sash, and as the two peaches alongside the extended bunch of grapes on the table. Look at my sex, Bacchus seems to be saying, which *isn't* one. It is the sensual pleasure I'm offering you, but it is *elsewhere*, it can perhaps be anywhere, inaccurately replicated in forms that substitute a visual sensuality for a concealed sexuality. The look that would center *our* look is itself decentered by such displacements, as well as by a certain incompleteness in the entire scene: both the wreath of ivy around the youth's head and the leaves of the bunch of grapes on the table end somewhere outside the painting. The self-withdrawing pose we originally noted could, then, be thought of not only as a partial concealment of the provocatively exposed body, but also as a redirecting of the viewer's solicited look to objects of undecidable identity (the phallus-sash, phallus-fruit) as well as to a space beyond the painting's frame (a visible space out of our field of vision).

The most compelling other center of interest in the painting is, however, the table. Formally, its horizontal position contrasts with the verticality of the youth's upper body (a contrast repeated, in detail, in the way the two peaches are lying on the table). With its heavy, stonelike quality, this mass of matter more closely resembles the tombstone jutting out at us from the *Entombment* than it does a table, and it brings into the work a threat to life more unsettling than the greenish hue of Bacchus's flesh. This is the unnamable finality of inorganic matter, unnamable because it can't be described, as the boy's sickness or death can, as the result of a process, the end of a history. The stony table brings into the *Bacchino Malato* the impenetrable enigma of matter that does nothing but persist, for all time, in its deadness. Nothing could be more different from the psychic enigma perversely proposed by the boy's smile and pose, although a certain

affinity between the sickly youth and dead matter is suggested by the repetition of the greenish gray of the youth's face in the table's surface. By juxtaposing the self-concealment perhaps inherent in the erotically soliciting pose with a radically other order of being, Caravaggio posits a mode of connectedness which, as we shall see, he richly elaborates elsewhere: the relation of the human body not to a more or less enigmatic human intentionality, but rather to a vast family of materiality in which community is no longer a function of reciprocal readings of desire.

But Caravaggio's main emphasis in these early works is on the apparently unfathomable nature of the erotic. Like the double movement of the youth's body in the *Bacchino Malato*, the tensed curve of the wrist in the *Boy with a Basket of Fruit* (1593–94; fig. 1.2) suggests a drawing of the basket toward the boy and away from the prospective buyer, at the same time that the painting fosters the illusion that we are looking at an offering. What is the boy offering us—the basket of fruit he seems to be claiming as his, or the highlighted right shoulder that is in effect pushed toward us? By implication, this question makes the open mouth undecidable: is the fruit vendor offering his merchandise, or has the mouth been opened to make the alluringly tilted head more enticing, thereby shifting the merchandise from the lush but partially withdrawn basket of fruit to the vendor himself? And yet it is easier to look at the basket of fruit as something we might possess than at the boy who, by looking directly at the viewer, reflects and resists the invasive gaze that would "take him in." He has only to look at us to remind us that the erotic gaze is itself invasive as well as inviting. His looking at us protects him from our looking at him. The invasiveness is, however, illusory on both sides. What we primarily see in looking at the fruit vendor's eyes is an emphatic point of light in his left eye. We are looked at by that light, and, as Lacan has said in his seminar on "The Gaze as *objet petit a*," what that light "paints" in the depths of our eye is not an object or a "constructed relation," but rather that which is "elided in the geometrical relation—the depth of field, with all its ambiguity and variability, which is in no way mastered by me." The eye is not a point of perspective from which we can look out at, measure, and appropriate the world.[2] Like the fruit vendor's eyes, the viewer's eyes are penetrated

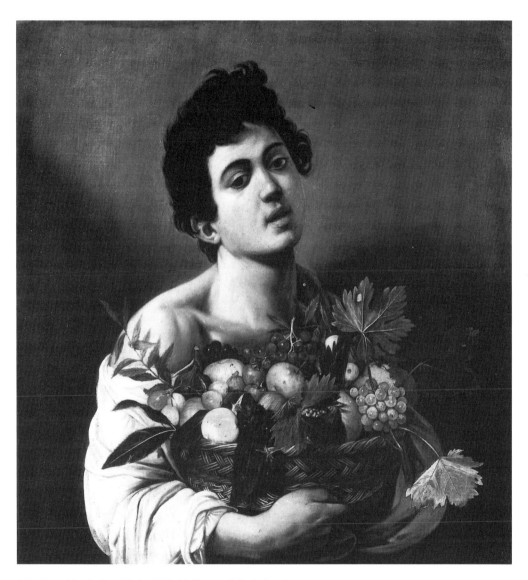

1.2 *Boy with a Basket of Fruit*, 1593–94. Rome, Galleria Borghese.

by a luminosity that has the ambiguous shimmering of a jewel, a luminosity that, from a cognitive point of view, illuminates nothing. The eye is an unreadable transparency (a fact made viscerally evident by the opening shot of Beckett's *Film*, in which Buster Keaton's glaucous eye, occupying the entire screen, is at once obscenely exposed and wholly impenetrable). The erotically provocative pose transforms the otherwise neutral unreadability of the eye into a willful reticence, as if we were being solicited by a desire determined to remain hidden. Let's note, finally, that the eye's brilliant opacity in *Boy with a Basket of Fruit*, which repels the look it solicits, is the principal element in a complex system of double movements. The fruit, which would otherwise be the passive object of an appetitive attention, is being withdrawn. What the boy thrusts toward us is the unreadability that keeps us at a distance. The one part of the basket's contents that has escaped the boy's protective embrace—the leaf in the lower right section—could be thought of as the most unambiguously available element in the painting; but it is limp and faded, highlighting, by contrast, the inviting ripeness of both the rest of the basket's contents and the boy himself.

In the paintings just discussed, erotic soliciting is countered by a movement away from the solicited viewer, a holding back that complicates the idea of erotic availability.[3] Or rather it is perhaps because of the movement away that we identify these looks and these poses as erotic. Inherent in this sort of erotic invitation is a concealment, and the concealment generates both what we recognize as the erotic invitation and possibly our own eroticized response to it. Sexiness advertises an availability that is somewhat opaque. The erotic here is a function of the noninterpretable address.

We should emphasize "here" because the word could, of course, be used to describe an invitation without concealment. In Georges Bataille, for example, the erotic refers to an unqualified openness, an availability uncomplicated by any reticence or secretiveness. Any such reticence might be the sign of an individuality resistant to that "communication" in which, for Bataille, the boundaries that define and separate individuals no longer exist. In this state of radical indistinctness, psychic and physical being is reduced to pure openness; being has become a receptive hole. While Caravaggio appears to "consider" this type of

address, or solicitation, he seems comparatively indifferent to a wholly nonre-
sistant openness. Even the frequently open mouths in Caravaggio's work (think
of the boy rushing away at the right of the scene from the martyrdom of St.
Matthew, as well as the boy bitten by a lizard) are more frequently figured as a
defensive cry against the world than as a readiness to be penetrated or invaded.
What seems to interest Caravaggio more is a body at once presenting and with-
drawing itself—a somewhat *enigmatic* body. The distinction between nonerotic
and erotic address might be, not that the latter solicits greater intimacy or fewer
barriers between persons, but rather that it solicits intimacy in order to block it
with a secret. Erotic address is a self-reflexive move in which the subject ad-
dresses another so that it may enjoy narcissistically a secret to which the subject
itself may have no other access. The subject performs a secret, which is not at all
to say that he or she has any knowledge of it.[4]

Is this secret homosexuality? It has come to be taken for granted in most
Caravaggio criticism that the painter himself was homosexual (or perhaps bisex-
ual), and that his work—especially the early portraits of scantily clad boys—
has a powerful homoerotic component. These perceptions, or assumptions, have
produced some astonishing critical documents. The most authoritative—and
tendentious—text for the documentation of homoeroticism in Caravaggio is
a 1971 essay by Donald Posner. For Posner, Caravaggio's "fleshy, full-lipped,
langorous young boys" assure us of the painter's homosexual tastes. These tastes
are portrayed in an innocently spontaneous manner in such early works as *Boy
with a Basket of Fruit;* they receive a slyer, more sophisticated treatment later on
in the *Concert, Bacchus, Boy Bitten by a Lizard*, and *Lute Player.* The representation
of a boy being bitten by a lizard seems to clinch the case for Posner. In this
painting, homosexuality is pointed to by the fact that the boy's "hands do not
tense with masculine vigor in response to the attack; they remain limp in a lan-
guid show of helplessness. His facial expression suggests a womanish whimper
rather than a virile shout."[5]

Such gibberish will surely inspire a "virile shout" from even the most lan-
guorous gay reader. Unfortunately, the discussion of Caravaggio's presumed ho-
mosexuality and his work's homoeroticism has not progressed since 1971 to

more invigorating intellectual exercises. The distinguished Caravaggio scholar Howard Hibbard remains sensibly neutral on the subject: "Whether Caravaggio was essentially or exclusively homosexual is far from certain." It is, however, generally agreed that when Caravaggio quotes Michelangelo (in such works as *Victorious Cupid* and *St. John the Baptist with a Ram*) he seeks, as Hibbard puts it, "to tear away [Michelangelo's] idealizing mask" and to expose "the true source" of his devotion to male nudes.[6] To what extent homosexual impulses are also "the true source" of Caravaggio's own devotion to partially clothed young men remains a subject of lively debate. As recently as 1995, Creighton Gilbert tensed, as it were, with masculine vigor in order to defend Caravaggio's heterosexuality. Gilbert goes to great lengths to show the unreliability of the hostile testimony given by Tommaso Salini during the 1603 judicial hearings of a lawsuit in which the artist Giovanni Baglione was suing Caravaggio for libel, testimony about Caravaggio's having shared with a friend a *bardassa* ("a male who takes a female role in social and sexual behavior"). As far as the paintings are concerned, Gilbert argues that in making Bacchus "quite soft as well as fat," Caravaggio was merely following a convention in representations of Bacchus. The hired male model is common around 1600, and muscles were a qualification for the representations of male nudity that were becoming more frequent. Caravaggio's youths are "boasting of [their] sexual success in naked pleasure" (Creighton invokes the heterosexually [?] heady atmosphere of the locker room in contemporary American high schools), and Caravaggio's Cupid is for Gilbert "cheer[ing] on heterosexuality at age twelve."[7]

Gilbert's analogies from Caravaggio's youths to raunchy American adolescents of the late twentieth century are not the most persuasive argument for Caravaggio's heterosexuality. At his best, Gilbert emphasizes the differences between contemporary and Renaissance perspectives on male beauty and homosexuality. Furthermore, as he writes, the idea that Caravaggio may be "hinting" at homosexuality in his work is itself a modern prejudice. When same-sex love is the subject of fifteenth- and sixteenth-century painting, it is generally presented in a direct and explicit manner. On the other hand, it could be said that while a heterosexual artist such as Annibale Caracci would have no trouble paint-

ing a frankly homosexual scene (there are, for example, two small homosexual scenes on the Farnese ceiling), artists with complicated feelings about their own homosexual impulses might feel less comfortable about treating such subjects directly and might, like Michelangelo, be able to express those impulses only through an idealized treatment of the male body in works with nonhomosexual subjects (such as *David* and the *Creation*). Nothing *forbids* an indirect presentation of the homoerotic, even in a period when direct presentations were acceptable. (Acceptability is, moreover, an historical variable even within the sixteenth century: after the Council of Trent [1545–63], nudity and pagan themes, many of which had homoerotic components, were officially condemned, although they hardly disappeared from post-Tridentine art.)[8]

Indeed, Caravaggio may be indicating his taste for homoerotic subjects through his androgynous male figures, figures at once muscular and yet recognizably "feminine" in some of their poses and expressions. Since antiquity, the androgynous had been associated with effeminacy and *therefore* bisexuality or homosexuality.[9] This code might lead us to reconsider a favorite contemporary dogma about the differences between modern and premodern notions of sexuality. The identification of the androgynous male figure with homosexuality suggests not only that "the homosexual" existed long before nineteenth-century sexology elaborated it as an object of medical attention and social surveillance, but also that it already consisted in the form most familiar to modern definitions: a woman's soul in a man's body. While a homosexual androgyne, strictly conceived, could only mean a male-female who would desire other male-females, the fact that androgyny operated as a code for male homosexuality—that is, desire of a male for another male—suggests that the androgynous subject was not seen as belonging by nature to both sexes but rather as a kind of corruption of one sex by the other, that is, as a feminized male. From this perspective, androgynes are freaks: they are male bodies anomalously harboring female desires.

Similarly, Proust evokes the myth of androgyny in the essay on homosexuality that opens *Sodome et Gomorrhe*. The invert gives himself away when his female soul—like a disembodied spirit seeking the incarnate form it has been unjustly denied—"take[s] advantage of the narrowest apertures in her prison

wall to find what was necessary to her existence," and makes herself "hideously visible" in the invert's body. The very hair on the invert's head gives him away: unbrushed, undisciplined, as he lies in his bed in the morning, "it falls so naturally in long curls over the cheek that one marvels how the young woman . . . has contrived so ingeniously" to manifest herself in its "feminine ripple."[10] No longer on its guard, the invert's body might be painted as an androgynous body; and having thus been feminized, it would be recognized as belonging to a homosexual. If Proust calls this visibility of the invert's female soul "hideous," it is because his emphasis here is on homosexuals not as desired objects but as desiring subjects. The androgyne becomes freakish when he/she is viewed as a male body with female desires. By the same token, however, the androgynous youth legitimizes heterosexual male desire for boys—legitimizes it *as* heterosexual. If men who desire androgynous males "really" desire women, the androgynous youth can be represented as beautiful. The question of the latter's own desires becomes not only irrelevant but also a potentially dangerous speculation that might lead to some troubling general conclusions about the "hideousness" of *any* same-sex desire. If homosexual desire renders a man effeminate and potentially androgynous, who knows when the adult male lasciviously enjoying the male youth's feminized body might suddenly begin showing a feminine ripple in his own hair, a visible sign of the imprisoned woman within *him* struggling to be free?

While the association of effeminacy with homosexuality is hardly a modern invention (earlier periods viewed at least the "passive" partner as, in essence, a woman), the characteristically modern move in Proust's discussion is to evoke androgyny within a discussion of the psychology of desire. Once the androgynous male's desires are centered, he risks becoming "hideous"; looked at only as a feminized body, he can be admired and even desired. Thus, it is probably anachronistic for Posner to call Caravaggio's Bacchus "depraved." Posner refers to Bacchus's "proposal," which he finds "indecent," thus drawing our attention to what the youth presumably desires from us. But while this "overfed, cosmeticized youth" may be less seductively appealing than the rosy-cheeked, fresh-

looking fruit vendor (but less appealing to everyone?), nothing points to his de-praved intentions except an irrelevant attempt to get inside his desiring skin.[11]

In large part, the homoerotic elements in Caravaggio's work are inferred from the way we think his contemporaries might have read his work. Indeed, perhaps all we can say with any confidence is that if viewers of Caravaggio's time found his youths androgynous, they may have concluded that he was represent-ing homosexual youths. And, whatever our suspicions may be, nothing really justifies our believing in an exact correspondence between Caravaggio's interest in such subjects and a particular (homosexual) identity. Finally, even if such a correspondence were justified, it would be unfortunate. For it would ignore what we take to be the greatest originality of these paintings: their intractably enigmatic quality. Caravaggio's enigmas are not meant to be read. At least since Oedipus, the enigma in Western civilization has been an epistemological chal-lenge. Its unreadability has been fantasized as provisional and, far from blocking knowledge, the enigma holds forth the promise of new knowledge, of ex-panding the field of epistemological appropriations. Caravaggio resolutely re-jects opportunities for such expansions. The distinction between heterosexual and homosexual reduces soliciting to a sexual identity. It makes the soliciting look transparent: homosexuality is the unveiled secret, the truth thanks to which, as the Proustian narrator says of Charlus when he discovers that the baron's de-sires are for other men, "everything that hitherto had seemed . . . incoherent became intelligible, appeared self-evident."[12] Now we "know" Charlus, just as we would presumably know Caravaggio better if we could confidently identify his works as homoerotic and Caravaggio himself as homosexual. The secret is an accident—or a defense that can be broken down—on the way to knowledge. Caravaggio's enigmatic youths propose something quite different: the secret is inherent in their erotic appeal, although there may be nothing to know about them. A provocative unreadability is presented as an occasion that might lead to a sexual arousal. Sexual identities, however probable, deprive these works of their erotic charge. Caravaggio's enigmatic bodies have not yet been domesti-cated by sexual—perhaps even gendered—identities.

WHERE TO LOOK?

We are interested in Caravaggio's work as a visual speculation on the meaning and the conditions of knowledge. We infer this speculation from Caravaggio's experiments with relationality. One such experiment seems to propose the erotic enigma as defining the terms of a relation, as that which might stimulate us into initiating connectedness. But even in his early paintings, that blocked connectedness is juxtaposed with other possibilities—possibilities that encourage us not to be satisfied with a relationality grounded in the erotic secret and, more generally, with forms of intersubjective knowing that assume a hidden unconscious.

Other versions of the insistent look can be seen in works in which Caravaggio places the solicited subject within the painting. Now the center of interest is a look apparently anxious to decipher another look or another presence. From this perspective, we will briefly discuss two very different paintings: the *Fortune Teller* and the *Calling of St. Matthew*, both of which not only demonstrate the range of Caravaggio's imagination of the soliciting gaze but which will also help us to unfold the complex logic of both looking and of secrets in Caravaggio. There are two versions of the *Fortune Teller*, one in the Louvre and the other in the Capitoline museums in Rome.[1] The Louvre painting is generally praised for what Mina Gregori calls "its refined composition, its uniformly high quality of execution, and its more acute description of the psychological relationship be-

tween the figures." The painting is, for Alfred Moir, "an elegant satire of human folly," and, for Gregori, the moral message of both versions is "the pitfalls that a youth might encounter." The Capitoline version (1593–94, fig. 2.1) has been seen as the artist's first thoughts on a theme he would develop later; Gregori describes it as having the instantaneous character of a hastily drawn street scene Caravaggio would have copied directly from life. But it is precisely the "finished" quality of the Louvre version (with, for example, its rich play of light and shade, its more elaborate gesticulatory motifs) which, in our view, makes it inferior to the Capitoline work. There is more going on in the carefully painted Louvre scene, and more of an attempt to define the narrative. We are given a psychological anecdote: the "radiant . . . pretty and transparent" youth, as Moir describes him, more baby-faced than in the other version, conscious of the gypsy's attentions, trying to look indifferent, with the "sly and complacent" gypsy girl perhaps watching the youth's face for the effect of "her suggestive caress of the mount of Venus" on his palm (or, as Giulio Mancini suggested, around 1620, for a sign of his awareness that she is stealing his ring).[2]

In the Capitoline version the young man's face is prominently on display, obviously there in order to be seen (his head is positioned forward while the girl appears to be retreating slightly toward the background), at the same time as his features are expressive of nothing more than that positionality—that is, their availability to another's gaze. Unlike the fruit vendor and, to a certain extent, the young man in the Louvre version of the *Fortune Teller*, the Capitoline nobleman is not marketing his own desirability. The erotically soliciting gaze of the other male figures we have looked at would at once complicate and deproblematize this curiously blank look. The very suggestion of a secret operates less as a barrier to communication than as part of a familiar code that defines certain communications as erotic. What the secret is—or whether a secret even exists— is irrelevant to the intelligibility given to a relation by the mere appearance of a secret. The Capitoline youth's facial expression is at once more superficial and more challenging than that of his Louvre counterpart. The gypsy's calculations appear to have been defeated by that physiognomic puzzle; her search into the boy's destiny has shifted from what is now her inactive hand (no longer probing

2.1 *The Fortune Teller,* 1593–94. Rome, Pinacoteca Capitolina. (Also plate 2.)

the secrets of his palm, as in the Louvre painting), to her extraordinary spying look. It is as if she had come to realize that his "secret" is not in the lines of his hand but in his look, a look impersonally directed toward her, as if she were nothing more than an accident, or a punctuation, in some larger indefinite space. It would be her mistake to read him as critics have read the painting, as having psychological intentionality. His blank, or better, disinterested availability to her gaze raises what can only be, for the fortune teller, an anguishing question: how are the two connected? Her professional answer, so to speak, would have been that she can see and speak (pre-dict, say ahead of time) his narrative extensions into his future. But his look suggests other types of extension: not toward her as a psychologically or socially individuated presence, but toward her as an occasion for formal extensions of his own physical presence (the upper part of her outer garment, for example, prolongs the diagonal shape of his sword). The fortune teller is spying on the young man's face as if his face had the decipherable lines of his palms. But we see her perhaps beginning to realize that there is nothing to read there, that his "secrets" are all visible, and that she herself contributes to that visibility, to what Merleau-Ponty would call the fragment of being radiating from him within the universal flesh of the world.[3] We are, then, beginning to see that the concealment spoken of earlier can perhaps be demystified, or that art can displace the secrets of the fascinating gaze, thereby redefining the terms of, and the responses to, a fascinated interrogation of that gaze.[4]

It is also a question of the interpretation of a soliciting look in one of Caravaggio's most remarkable religious paintings, the *Calling of St. Matthew* (1600; fig. 2.2). Here, however, the soliciting is wholly unambiguous. It is Christ beckoning to Matthew to follow him. But the painting satirizes such unidirectional invitations. Christ's eyes are veiled, his outstretched hand seems somewhat deformed and points rather limply at Matthew,[5] who prolongs the gesture by pointing—more forcefully than Christ himself does—perhaps toward himself, perhaps toward the figure just to his right. This is not the fascinated perception of a visual enigma: Matthew and especially the boy to his left leaning toward him both look with a detached (ironic?) puzzlement at the darkened, pictorially unimpressive source of this intrusive calling. Matthew, the story tells us, will

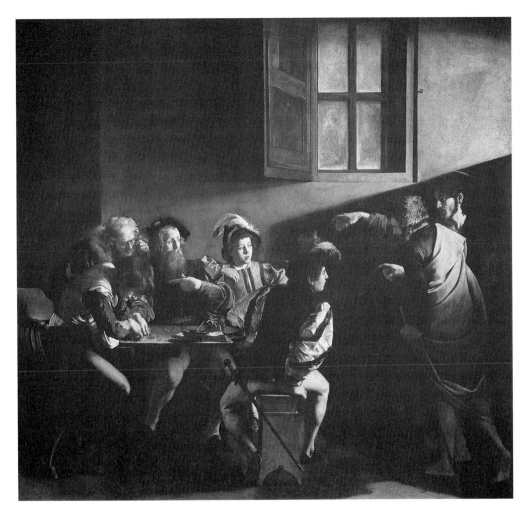

2.2 *The Calling of St. Matthew,* 1600. Rome, San Luigi dei Francesi. (Also plate 3.)

follow Christ, but Caravaggio has chosen to paint the moment before he consents, the moment of suspension, of the slightly shocked response to a soliciting presence that weakly but unambiguously asks for nothing more interesting than that it be followed. In what may be a commentary on the unseductive nature of *that* invitation, the young man with his back to us appears to be looking elsewhere, somewhere beyond Peter and Jesus, to another source of light. His turning in that direction could be read as the beginning of a movement responsive to that other call, to a source invisible in this painting but which implicitly criticizes the represented caller as a visible element denying the invisibility, or the latency of the visible, to which he belongs. The youth in the *Fortune Teller* says: Recognize my anonymous visibility. Christ implicitly proclaims: Recognize me as the center to which all things return. The Christian version of the soliciting presence is a repression of both the erotic secret and of what might be called an impersonal narcissism. In this calling that cannot go unheeded, that is at once enfeebled but perfectly clear, Caravaggio has painted Christ, and Christianity, as an antierotic and antimetaphysical defense. Christianity fosters the illusion of intelligible messages and of readable bodies.

Matthew's confused response to the summons might be reformulated as an unintended judgment of the painter's technique: has Caravaggio "properly" focused Christ's gesture and look? Unlike the looks of the *bacchino malato* and the fruit vendor, which seem directly to address the spectator, the looks directed somewhere within Caravaggio's paintings are often ambiguously focused. The nobleman answers—or rather ignores—the fortune-teller's searching gaze by turning in her direction only to look toward some indefinite space beyond her. Like the young man in the *Calling of St. Matthew* who is gazing at some unspecified source of light outside the painting, the visual attention of secondary figures in several other works is turned away from those works' principal episodes. Even in paintings in which central figures such as Christ crucified or the dead Virgin would seem to command the attention of all those around them, it is doubtful, as we shall see, that anyone is heeding that command. Less dramatically but no less significantly, even when Christ appears to have successfully drawn nearly everyone's look to himself, gazes can be peculiarly off, not quite centered on the object of their apparent attention.

This is the case in the Brera *Supper at Emmaus* (c. 1606; fig. 2.3), in which the disciple seated to Christ's left appears to be looking somewhere just off Christ's left shoulder while the head of the other seated disciple, whose face is largely hidden, is positioned to suggest a look directed somewhere between Christ's head and his raised hand. The old woman to the right is staring vacantly into space, while the inn keeper standing next to her is looking down toward the table with an oddly self-absorbed fixity. This *Supper at Emmaus* powerfully centers Christ, at the same time as it subtly decenters him. He nearly fails to be the place where all gazes converge, either because the gaze just misses him or inexplicably becomes self-reflexive as it takes him in. The meeting at Emmaus is an epiphany for the disciples—they recognize their host as the resurrected Christ. But Caravaggio has not painted a relation to a uniquely venerable object; rather, he reveals to his spectators a certain equalizing of value among objects in space. There are several pairings in the work, pairings that ignore the boundaries not only between persons but also between living human beings and inanimate matter. Christ's raised right hand is paired with the raised left hand of the figure to his right; his left hand is resting on the table next to the similarly positioned right hand of the other seated disciple; there are the two pieces of bread, one already broken, the other intact; and there is the curious repetition of the folds of wrinkles on the old woman's brow in the ribs of meat on the plate she is carrying. Each member of each couple remains distinct. Even the two hands resting on the table are contiguous without touching. Indeed, the possibility of contiguity as the subject of this painting is suggested by the minuscule space separating the sharply outlined little finger of the apostle to Christ's right from the unbroken piece of bread. A *space between* keeps all these paired objects apart. The couple never becomes one; each member of each pair echoes its partner without sacrificing any parcel of its own space, of an individuality that can be paired but that cannot essentially be repeated.

Given the central motif of a blessing in the *Supper at Emmaus*, we might conclude that Caravaggio has painted the sanctification of all objects in space. But how exactly should we look at a world in which there is no supremely privileged object, no recognizable and recognized point to focus the spirit and the gaze? The process of sanctifying equalization we have just described requires

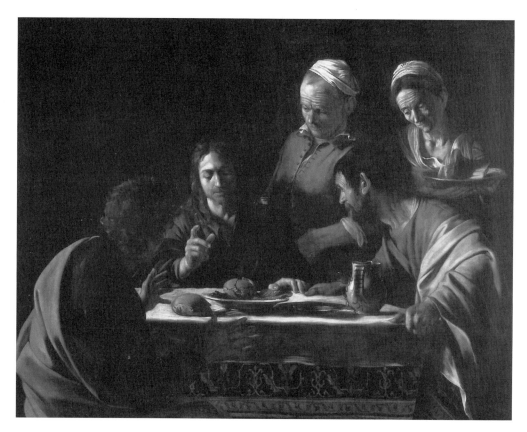

2.3 *Supper at Emmaus,* c. 1606. Milan, Pinacoteca di Brera.

a new kind of look on our part, a look bound to be at first a disoriented look. Caravaggio's Christian subjects call for an unambiguously focused look that Caravaggio seems unable or unwilling to give them. The supposed defects in his perspectival technique are the necessary consequence of this inability or this unwillingness.[6] The mastery of perspectival technique presupposes a certain confidence about locating spatial priorities. As Leon Battista Alberti had suggested in his 1435 treatise *On Painting*, perspective makes possible visual narrative, the proper arrangement of elements in the painting's *historia*. The connection between the two is spectacularly confirmed by Poussin; as Louis Marin has shown, the masterly manipulation of depth of field allows Poussin to tell stories, to transform the spectator's instantaneous perception of a visual space into an experience of narrativized time.[7] In Caravaggio, on the other hand, a certain awkwardness of—or indifference to—techniques of foregrounding and distancing is only one sign of what we are analyzing as a profound uncertainty about relational priorities. It is as if nearly everyone around the ambiguously centered Christ of Caravaggio's work knew, as Caravaggio himself seems to have known, that no one has the authority to center our gaze, to define its primary relation. That Caravaggio knew that, and principally painted religious subjects in which relational primacy could not by definition be questioned, is immensely moving. Almost nothing else was available to him, and so he truly was—even more, say, than one of the great social pariahs of our own time, Jean Genet—an outlaw, outside all the relational laws given to him. As the figures proliferate in Caravaggio's work, frequently looking at some unidentifiable point beyond the painting, Caravaggio's aloneness becomes all the more visible. For his figures, like him, perhaps like us, know that it almost has to be started all over again, but for the moment they, he, we simply don't know where to look.[8]

MORTAL MEDITATIONS

Boy with a Basket of Fruit, the *Bacchino Malato*, and the *Calling of St. Matthew* all represent a soliciting presence. In the *Boy with a Basket of Fruit*, as well as in Caravaggio's other early works, the address is at once transparent and enigmatic, a combination central to the seductive or erotic appeal of Caravaggio's solitary male figures. The soliciting in the *Fortune Teller* is more ambiguous. By extending his hand, the young man is asking (or so it would seem) to be read; the gypsy presumably possesses his secrets, or his future. But rather than confidently search his palm, she spies on his face, as if looking there for the key to who he is. But since, as we have argued, his "secrets" are entirely visible, since he is nothing more than his presence (and the spatial extensions of that presence), he answers her probing look with a very different kind of invitation. Recognize, he might say, that there is nothing hidden to be read, that my "secrets" are entirely visible in the largely unnoticed ways in which we are already connected—connected not because you know me, but because we occupy, punctuate, and define a common space.

If Jesus' summoning Matthew to follow him is the least interesting of these solicitations, it is certainly not because Caravaggio unreflectively dismisses Christianity. The subjects of nearly half his paintings are taken from the New Testament, and much of the work executed for specific churches—even when

we take into account the rejected altarpieces of Caravaggio's last years in Rome—was accepted and presumably admired by the ecclesiastical authorities that commissioned it. It has even been argued that aspects of his paintings criticized as showing irreverence toward their sacred subjects (the realistic physical details in his representations of saints and especially of the dead Virgin) faithfully reflect populist tendencies within the Church at the time of the Counter-Reformation.[1] But in being responsive to this tendency, Caravaggio perhaps found the freedom to reflect, not only on the profound humanity of Christianity, the appealing ordinariness of its origins, but also, in more unsettling ways, on Christianity as a particular mode of structuring relations.

Caravaggio "rethinks" Christianity through his treatment of certain visual motifs central to it, especially, as we have begun to see, certain gestural motifs. He proposes continuities between what we would ordinarily think of as vastly different categories of experience: the erotic come-on and Christ's summoning his future disciple to follow him. Both are modes of soliciting the other's attention, of calling forth an interested response. Christ's pointing toward Matthew and the provocative look and pose of the *bacchino malato* are ways of initiating a relation; and while infinitely more appears to be at stake in the gesture of Jesus, that gesture radically simplifies relations while the look of the *bacchino* immediately complicates them. Christ's call is so clear that it could also be read as an injunction to renounce the unreadable. It is therefore all the more interesting that in Caravaggio's version of the Biblical episode, Matthew appears not to understand Christ's gesture. If the latter is unambiguously a summons, it is apparently not clear to whom the summons is being addressed. In the painting's central space Matthew repeats Christ's pointing *as a question*.[2] In a sense, then, the work's subject is not exactly "the calling of Saint Matthew," but rather Matthew's puzzled response to the call. The time of the painting is—somewhat ironically, given Matthew's eventual recognition of the call—that moment when Matthew himself becomes unreadable, when he is between being the tax collector Levi and his new identity as Christ's disciple. Caravaggio's unsettling reflection on the episode is therefore manifested in his displacement of the story's focus from a weakly delineated Jesus to the more boldly designed representation of Matthew as an astonished interrogation.

———

The Calling of St. Matthew is a questioning of the sense, as well as the power, of certain gestures. In Caravaggio's work, Christianity is judged, to a significant degree, by the kinds of messages the gestures associated with it bring into space. The life-giving power of the divine gesture is most spectacularly manifested by Christ's raising of Lazarus from the grave. In Caravaggio's representation of that episode (one of his last works, painted during his stay in Messina from late in 1608 to the middle of 1609 on his way back to the Italian mainland from Malta; fig. 3.1), we have another "calling" through the gesture. But whereas the target in the earlier painting suggests that the pointing may be somehow *off* target, or that it lacks the power to be at once recognized and obeyed, in the *Resurrection of Lazarus*, as in the Gospel account, Christ's gesture literally calls Lazarus back to life. And yet Caravaggio's work could hardly be said merely to celebrate the success of that gesture. The painting is one of his largest, and to see it (rather than a reproduction) is to be struck by the differences between the two groupings. On the left, there is the crowded grouping of Christ and the six figures behind him and above his outstretched arm. The four figures to the right—Lazarus's sisters Mary and Martha, Lazarus himself and the man holding him—almost seem to be in another painting: they are more prominent than the huddled group to the left (both in terms of light and the generous space given to them), and nothing indicates their awareness of *Christ's* presence. (The principal structural continuity between the two parts of the work is the diagonal made by Lazarus's body: his legs extend into the group to the left.) The two figures half-turned toward Jesus narratively connect the two groups, but the relation thus established is ambiguous. Their positions and their curious or surprised expressions suggest that Jesus is not the cause of their lifting the tombstone so that Lazarus may be raised up, but rather that he has interrupted their activity. Both structurally and dramatically, Christ could be read as an intruder. If we didn't know the story, we might feel that the resurrection of Lazarus was already taking place before Jesus unexpectedly appeared on the scene, an appearance the group to the right seems not yet to have noticed.

In Lazarus, we have a metaphoric rehearsal of Christ's own destiny. As Hibbard writes: "The unusual pose of Lazarus may be meant to foreshadow the crucifixion of the Christ who resurrects him, thereby encapsulating the Passion

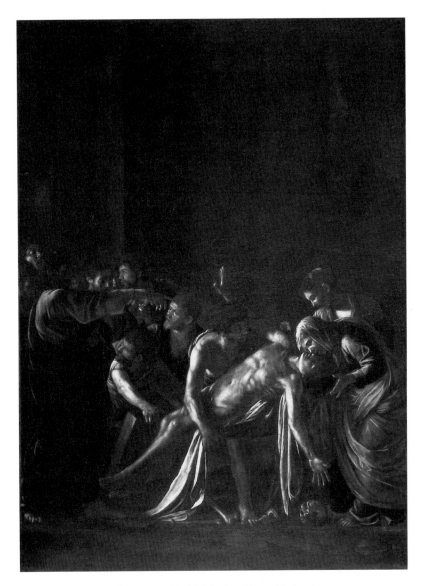

3.1 *The Resurrection of Lazarus,* 1608–09. Messina, Museo Nazionale.

and the Resurrection in one miracle." This suggestion becomes all the more plausible when we note the virtual cross formed by Jesus' outstretched arm and the head of Lazarus's sister and, on the vertical axis, the line going from Lazarus's right hand to the left leg of the man holding him. But to what extent does the representation of Lazarus preempt the events it also presumably encapsulates by reformulating them in strictly human terms? There are not only the structural and expressive elements that relegate Christ to the sidelines of Lazarus's resurrection. There are also aspects of that resurrection which distinguish it significantly from the infinitely more portentous event it anticipates. Hibbard recognizes something "unusual" in Lazarus's pose, especially in the position of his arms. He approvingly refers to Herworth Röttgen's argument that "the right hand, which catches the light, is deliberately raised in an antique gesture of acclamation, whereas the left arm leads our eyes down to the skull (we think again of Golgotha) as if to show that Lazarus is in a struggle, both physical and psychological, between death and life."[3] But Christ will die and be buried, and will then reappear, resurrected; there is nothing in *that* resurrection that corresponds to the between-ness Caravaggio emphasizes. This between-ness means that Lazarus is neither dead nor alive, or that he is both. He is, in any case, not readable as either one or the other, and his unreadability is reinforced by the irreducible ambiguity of that highlighted right hand. Is it "an antique gesture of acclamation"? Perhaps. But if we fix our attention on what is going on *here*, within Caravaggio's painting, the gesture can also be read as simultaneously open to contacts and repelling them. Whereas the left hand appears more ready to receive, the right hand, strategically placed on the same horizontal line as Christ's head, could be thought of as at once reaching out to receive the gift of life and (unlike Michelangelo's Adam of whom Caravaggio's work ironically reminds us) pushing that gift away. The entire body is ambiguously positioned: we know that it is being raised, but the man holding it could just as well be lowering it. Lazarus is the meeting of the energy of life and the energy of death.

This double pull is a tension inherent in the human. It is a natural tension wholly at odds with Christ's resurrected being announcing its victory over death. If one of the possible meanings of Lazarus's gesture is that he is resisting Christ's

gesture, then he, unlike Christ, is claiming for himself the human prerogative of mortality—not the provisional mortality of Jesus, but the fundamentally unrepresentable double movement of life and death that accompanies every moment of human existence. Death does not merely follow life; it is a movement *in* life. Lazarus's "unusual pose" is perhaps an allusion to the unresolvable ambiguity of a body that can't help being "lowered" every time it is "raised," that moves toward its destruction with (and within) each of its affirmations. From this perspective, the peremptory quality of Christ's gestures—follow me! return to life!—could almost be thought of as a blasphemous invasion of space. Far from make sacred the space it enters and designates, Christ's gesture traces the designs of a merely readable message, whereas Lazarus's enigmatic gesture reminds us that the definitive immobility that awaits us is actually, during the time of life, the source of a dynamic tension with which our gestures energize space.[4]

To say that Christ's gesture in the *Calling of St. Matthew* and in the *Resurrection of Lazarus* impoverishes space is not to deny his importance in the history of how the passage between life and death has been imagined. Christianity tells a story of spectacular transitions between Eternal Being, human life, and death. To paint this story—from the Annunciation and the virgin birth to Christ's Ascension and the Assumption of the Virgin—was necessarily to engage in a kind of visual reflection on it. The critical nature of that reflection was quickly recognized, although in terms that now seem to us somewhat beside the point. The reception of the *Death of the Virgin* (1605–06; fig. 3.2) is especially instructive. Commissioned for Santa Maria della Scala in Trastevere in Rome, it was rejected by the Carmelite fathers of the Church. On the advice of Rubens, it was purchased in 1607 by the duke of Mantua. In his biography of the painter, Caravaggio's contemporary Giovanni Baglione writes that the painting was rejected because Caravaggio had depicted her "con poco decoro," "swollen and with bare legs." In his *Trattato*, written around 1620, ten years after Caravaggio's death, Giulio Mancini explains that the church fathers had the *Death of the Virgin* removed because Caravaggio had used a courtesan as the model for the Madonna, an example for Mancini of modern artists' deplorable tendency to portray the virgin "like some filthy whore from the slums." Finally, the seventeenth-century

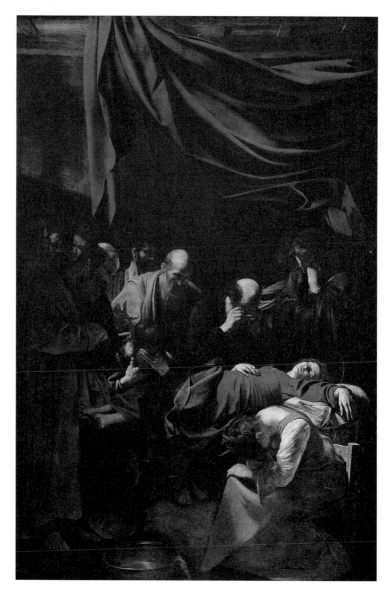

3.2 *Death of the Virgin,* 1605–06. Paris, Louvre. (Also plate 4.)

biographer Giovanni Pietro Bellori, in his *Vite de' pittori, scultori et architetti* of 1672, echoes these accounts and reproaches: *Death of the Virgin* was rejected "because the Virgin had been made to look too much like the swollen corpse of an ordinary dead woman."[5]

The transcendental aspect of Mary's death is certainly absent from Caravaggio's painting, although it is not merely Mary's swollen corpse that is difficult to reconcile with the idea of her death as a transition from earth to heaven. More generally, the emphatic horizontal structures counter the verticality of the Assumption. Caravaggio's representation of her death is, however, more interesting than a simple denial of the miracle associated with her dying. Far from opposing the "simply human" to the transcendental, Caravaggio reinvents the spirituality of the Virgin's death. Perhaps the most mysterious and original aspect of the painting is the floating red curtain above the bed. To say, as Hibbard does, that this curtain "fills the otherwise empty space at the top of the picture and is ultimately [?] to be understood as the bedhanging, pulled up to reveal the body,"[6] is to guess at why the curtain is there (it functions as a filler) and how it got there (it was pulled up from the bed), without saying anything at all about its effect once it is there. We know nothing about Caravaggio's intentions, and even stranger than making a stab at them is the invention of someone, within the fictive world of this scene, having raised the curtain before the figures we see settled in place and posed for the painting. What we do see are the similarities in color and, to a lesser degree, in form between the curtains and the Virgin's robe. And it is those similarities that heighten the contrast between Mary's inert body and the undulating, wavelike movement of the curtain. That undulating piece of drapery is the most alive part of the painting, as if there had been a transfer of energy to the curtain not only from the Virgin but also from all the static figures surrounding her. Mary, it should also be noted, is not completely inert: if the upper part of her body lies heavily on the bed, her legs seem to be floating. To a certain extent, she is being raised—not in a vertical assumption into heaven, but rather in a sort of horizontal lift toward the curtain. There is, this painting obliquely reminds us, no personal immortality—and we can't be consoled for the loss of a person—but the movement associated with life never stops circulating. Here the circulation is in part motivated (in its color and form,

the curtain recalls, and extends, the Virgin) but it is also indiscriminate: anything will do—a floating piece of cloth—as an agent of mobility. Death not only fails to destroy but even serves to highlight the depersonalized resourcefulness of the real. The curtain is the Virgin's only afterlife, and it interests us more than she does now—which is perhaps why no one is looking at her. It is as if the Apostles don't know where to look, although their failure to focus on the brightly lit narrative center of Mary's face is a cue for *us* to de-narrativize our spectatorial gaze and to look above, where both much less and much more are happening than "the death of the Virgin." [7]

The body thinks, and its thinking is energized, even sensualized, by the death inscribed within it. This is, as it were, the philosophical argument we infer from two other powerful representations of death: the Galleria Borghese *St. Jerome Writing* and the Vatican *Entombment*. In the former (c. 1605–06; fig. 3.3), Caravaggio shows us the scholarly saint (St. Jerome translated the Hebrew and Greek Bible into Latin) engaged in intellectual activity, but the painting emphasizes the physicality of that activity. While Jerome appears to be wholly absorbed by books as well as by his own writing, we don't see him writing or even reading. His pen is poised in midair, and his eyes seem to be focused on a point just off the left edge of the page to which his book is opened. He is between reading and writing, as well as between what he may have just written and what he will go on to write, and what he has just read and what he will read when his eyes return to the book he is holding. This between-ness is emphasized by the painting's most impressive single element: the strikingly sinuous arm between the death's-head and the saint's head. At the moment Caravaggio represents, Jerome's intellectual activity is centered in his suspended arm, much as the painter feels his creative intention in the arm he holds out toward his canvas. This is the moment when the brush, like the saint's pen, is between the traces it makes on the canvas, traces first felt as muscular pressures. In Jerome's arm, Caravaggio paints the passage of intellectual energy from the head to the page (or the canvas); he gives us an image of philosophy or of art being carried by the body.

The source of this energy is ambiguous. Is its point of origin St. Jerome's head, or the skull? The painting is strongly centered: two virtual diagonals—one starting at the death's-head, the other originating toward the back of the saint's

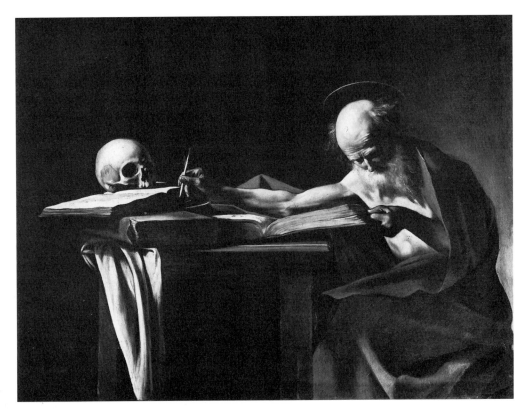

3.3 *St. Jerome Writing,* c. 1605–06. Rome, Galleria Borghese.

head—meet within the double triangle just above Jerome's forearm at a point directly opposite the painter's, and the spectator's, probable position. The work is structured to center our look about halfway between the two heads, neither one of which is privileged. The saint's expression would naturally arouse our interest, but his head is lowered and his face recedes from our view while the skull is thrust more directly toward the viewer. The emphasis on reading and writing suggests movements from left to right, and if we were to read the painting like a page of life on which old age and death are written, Jerome should logically be to the left of the skull. Indeed, this is the order chosen by Caravaggio for the Malta *St. Jerome Writing*, but in the more original Borghese work death is shown to be, as it were, at the beginning of the page. Caravaggio has represented neither a progression from life to death nor, even more banally, the vanity of human thought in the face of mortality, but rather the nourishing of thought by both life and death. The source of the intellectual energy being carried by Jerome's arm is both in the living man's consciousness and in his death. More exactly, his death is already in his head; it has been there since the beginning of life's text. Caravaggio articulates that dual presence both by separating the live head from the death's-head and connecting them through the arm that conducts an energy ceaselessly circulating between the two. From the centered triangles, our eye moves between the skull and the saint's head, unable to settle on either one as an origin or a terminal point.

We think, we write, we paint under pressure, a pressure that is in part the "knowledge" the body has of its own death. This knowledge, which we are perhaps born with, directs and inflects our implication in the real; it is a powerful formalizing element of the energy passing through the extended arm about to write, about to paint, about to designate a follower, about to welcome or to repel the other's beckoning gesture. The particular artfulness with which each of us moves through space is the creation of our mortality, the expression, or pressing outward, of death's inscription within our bodies.

Is the remarkable sensuousness of St. Jerome's arm also meant to suggest that the death inscribed in the living body's movements can also be a source of its sensual appeal? The compatibility of death with sensuality is the subject of

another extraordinary work: the Vatican *Entombment* (1602–04; fig. 3.4). Once again, the central sacred figure is virtually ignored. The only participant in the scene who may be looking directly at Christ is St. John, but his eyes are so veiled in darkness that it's impossible to say exactly where they are directed. The dispersed glances are not in themselves unusual in Entombment or Pietà scenes that include several figures, but the looking away from Christ's body is dramatically underlined by Nicodemus's aggressive stare out of the picture frame toward us. (The movement away from Christ's body is accentuated by the jutting corner of the tombstone, which appears to be thrusting itself toward the viewer, out of the picture plane.)[8] And yet it can hardly be said that, as in the *Resurrection of Lazarus* and the *Calling of St. Matthew,* Christ is relegated to a position of secondary importance. His massive, illuminated body is the immediate and powerful object of our visual attention. But the other figures in the painting give us the cue for what might be called a blinded gaze. It may be the light coming from within his body (no external source accounts for his illumination)[9] that makes it impossible to look at him. A visual absorption in Christ's blinding body can be manifested only by closed eyes or the averted gaze, or, most radically in the case of Nicodemus, by the absence of eyes. And it is the sheer physicality of the body that blinds, a physicality that has neither the ideality of Michelangelo's *David* nor the posed eroticism of Poussin's *Victory of Joshua Over the Amalekites* (1625). In the *Entombment,* Caravaggio has painted the sensuality of flesh in which death appears still to be circulating *as* energy. Christ's real death becomes for Caravaggio the dramatic metaphor in which we both see and are prevented from seeing what the ordinary movements of life hide from us: a body alive within its own death.

Such a body, infinitely appealing, cannot, however, be an object of desire. Death never teases us with the secrets of an erotic appeal; like the dead Christ with his eyeless face, it has no look with which to fascinate our gaze. Christ's body proposes itself as neither plenitude nor emptiness; it can therefore neither reflect our own sense of lack nor promise to restore us to an imaginary wholeness. This is the pure being-thereness of an edenic body, a body that does not need to be condemned to literal death to experience its own dying. The story

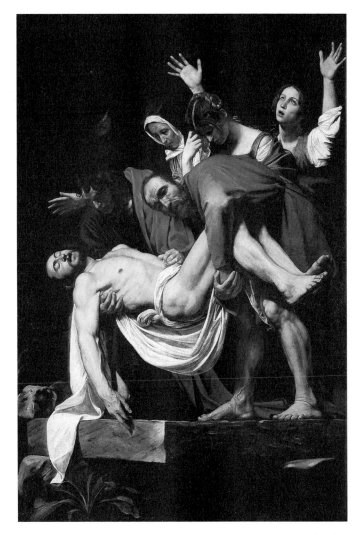

3.4 *Entombment of Christ*, 1602–04. Rome, Pinacoteca Vaticana. (Also plate 5.)

of Christ is ambiguous in this respect. It makes the distinction between life and death excessively clear, and it even proposes a form of life from which death has been eliminated. On the other hand, the absolute uniqueness of that story is the commitment of Christ's body to its own death from the very beginning of his life. In Christ, God chose to be born *in order to die*. The ethically primitive nature of that choice (the sacrifice of God himself was necessary to redeem humanity from sin) does not erase its more profound phenomenological significance as a parable of the human body's knowledge of its death.

The body can be fully loved perhaps only if we love that knowledge in it. To see such an awareness in another body is not to be mystified by a secret, as when we look at the erotically soliciting gaze; it is to be blinded by the seductiveness of a fully developed physicality. While the erotic gaze elicits a fundamentally paranoid fascination (what secret is being withheld from us?), we look away from the body whose death has become visible as part of the beauty of flesh. And this is perhaps because we recognize that the blinding body out there is also our own. In Caravaggio's *Entombment*, the sign of this recognition is the near invisibility of the others' eyes. We don't see their eyes because their blinding recognition is a self-reflexiveness, a seeing inward. To be wholly absorbed by Caravaggio's Christ is to obliterate the distinction between looking outward and looking inward. The eye is the threshold at which the two worlds separated by that threshold become indistinct from one another. Christ's body in the *Entombment* is the illuminated spectacle of the (internal and external) spectators' physicality. To be blinded by that light is, then, identical to an exceptional self-absorption. Having looked at its living death, consciousness knows the body it inhabits with a fullness it can never have as long as the body is—is thought to be—merely alive.

4

The Enigmatic Signifier

Caravaggio paints two kinds of concealment. The one to which we've devoted most of our remarks so far is designated through an eroticized address, and it is read as enigmatic desire. The other, hinted at in different ways in the *Fortune Teller* and the *Calling of St. Matthew*, is spatial though only partly visible within the painting; it is the "concealment" of an unmappable extensibility of being. To speak adequately of the first type of concealment invites a psychoanalytic look, perhaps the most refined interpretive look we have. Merely by positing the notion of an enigmatic subject we have placed ourselves on psychoanalytic ground. Indeed, Jean Laplanche has recently located the category of the enigma at the very point of emergence of what might be called the psychoanalytically constituted subject. He has spoken of an original and unavoidable seduction of the child by the mother, a seduction inherent in the very nurturing of the child. The seduction in no way needs to be intentional; as Laplanche puts it, "the adult world is entirely infiltrated with unconscious and sexual significations, of which *the adult too* does not possess the code." Adult sexuality is implanted in the child in the form of what Laplanche calls an enigmatic signifier—that is, a message by which the child is seduced but which he or she cannot read.[1]

Laplanche speaks of the seductive address mainly as an account of the structural formation of the unconscious: primal repression would be the making unconscious of those elements in the enigmatic signifier which infants can't

"metabolize," that is, which they are incapable of understanding through some form of symbolization. But the seductive address may be more general than that: *an ego is erotically solicited into being*. The seductive address Laplanche speaks of is, we suggest, embedded in the very calling forth of the infant's being as an independent subjectivity. Relationality constitutes being. In *Arts of Impoverishment*, we speak of Beckett's *Company* as a literary figuration of this originary soliciting of the human subject. In Beckett, the address is vocal: it is represented, or remembered, as someone on his back lying in the dark hearing an unlocatable voice summoning him to identify as his own the life he is being told about. Human subjectivity, Beckett implies, is always a response to an address; there is no presocial, solipsistic "I." The injunction to be, to have a life, is an injunction to answer a call; a human organism becomes a human subject only by recognizing and participating in a linguistic or a gestural sociality. The originating of a human being is the originating of relations.[2]

We must go further than this and ask about the nature of the being constituted by relationality. It is how we read the summons, the seduction, the soliciting that determines what or who we are. The inability to decipher the enigmatic signifier constitutes us as sexual beings, that is, beings in whom desire or lack is central. However peculiar it may seem to speak of desire as an epistemological category, we propose that desire as lack is constituted, originally, as the exciting pain of a certain ignorance: the failure to penetrate the *sense* of the other's soliciting—through touch, gesture, voice, or look—of our body. This failure is itself dependent on a more fundamental reading: the reading of the soliciting as a secret. The secrets of the unconscious may be nothing more than the introjection of the secrets the other involuntarily persuades us to believe he or she holds without allowing us to read them. The withheld being with which the other addresses us is the other's desirability.

To modify the way in which the human being is addressed would modify the relationality that constitutes the human as we know it. In *Arts of Impoverishment* we asked: "Is there a non-sadistic type of movement?" We raised this question in the context of Freud's argument, especially in "Instincts and Their Vicissitudes" (1915), concerning the fundamental antagonism between the ego and the external world. "At the very beginning, it seems, the external world,

objects, and what is hated are identical." Not only that: this repudiation of all the difference that threatens the ego's stability persists throughout life: "As an expression of the unpleasure evoked by objects, [hate] always remains in an intimate relation with the self-preservation instincts."[3] Within the Freudian scheme, we argued, the ego's profound mistrust of the world can be "overcome" only by a narcissistic identification with the hated object, one that masochistically introjects that object. This masochistic narcissism sexualizes our relation to the world at the same time that it eliminates the difference between the world and the ego. The project of *Arts of Impoverishment*, reformulated and pursued in new contexts here, was to investigate the possibility of ego-identifications (or ego-extensions, we would now be inclined to say) not reducible to a sexualizing shattering of the ego or to the sadistic project of destroying what is different from the ego.

Laplanche's notion of the enigmatic signifier could be thought of as a reformulation of the antagonism between the self and the external world. He implicitly locates the origin of this antagonism at the very moment when the subject is seduced into a relation. The seduction is a mystification: the child's body is erotically stimulated by unfathomable "messages" from another body. Because the adult's body carries a mass of sexual meanings in its contacts with the child, physical stimulation is inseparable from what Laplanche has called elsewhere the "shattering" of an ego unable to understand and to structure the stimuli by which it is being invasively addressed. There is, necessarily, and without any seductive intentions on the part of the adult, an imbalance between the latter's already complexly solicited and soliciting psyche and the comparatively meager resources of the child's inner world. The result of this original seduction is a tendency (operative in varying degrees) to structure all relations on the basis of an eroticizing mystification. If we feel not only, as Freud proposed, that others threaten the stability the ego must defend for its very survival but also, more dangerously, that we can be seduced by such threats, then it becomes reasonable to confront the world with paranoid mistrust. It is impossible for others to know the contents of their own address to us when that address includes the unintelligible ("nonmetabolized") unconscious sediments of the seductively enigmatic signifiers by which *they* have been addressed.

Like all painting, Caravaggio's work is about forms of connectedness in space. In painting his portraits of erotically provocative boys, it is as if Caravaggio experienced—or reexperienced—the fascination of the original seduction. For a painter, this experience was perhaps inevitably one of constricted space. The enigmatic signifier structures a relation according to fixed gazes—not only the gaze of the one being seduced, but also the gaze of the seducer, who is himself (or herself) seeking in the curious and subjugated look of the other the secret of his (or her) own seductive power. But his work also allows Caravaggio to experiment with a gaze diverted from a space circumscribed by a mutual fascination. The youth in the *Fortune Teller* raises the possibility of spatial interests not defined or directed by the imaginary secrets of the other. Perhaps the exploration of this possibility requires a suspension of strictly human interests, a removal from those existential contexts in which paranoid fascination is the human subject's spontaneous response to the other's soliciting (or even interested) gaze.

Caravaggio effects this removal by a betrayal of his subjects. The historical configurations of these subjects are reproduced in his painting, but at the same time the subjects appear, for the first time, as models of a relationality within which their historicity dissolves. The relations that emerge from this shift of register reformulate both intersubjectivity and metaphysics. Caravaggio is a crucial figure in the history of a suspicion fatal to the procedures and the confidence of philosophy: the suspicion that truth cannot be the object of knowledge, that it cannot be theorized. More exactly, the notion of truth itself is a consequence of the primacy given to knowledge. And knowledge "misses" being; it comes, so to speak, when we cease to remember that being happens not as a demonstration but as a kind of showing. To adopt a Heideggerean inflection, we might say that being "shines" in art.[4] In Caravaggio, this shining is literally rendered by that peculiar light that seems not to be projected on bodies from some locatable external source, but rather originates within the bodies themselves. The light emanating from Caravaggio's figures is the sign of their transformation from merely historical persons to ontological cartographers: Caravaggio re-presents them—which means here that he presents them for the first time—as mapping modes of being. Caravaggio's paint is the metaphysical X ray that compels us to see particular histories and particular myths as *instituting relationalities*.

———

5

ARTISTS AND MODELS

How might we imagine the move from historical subjects to modes of being? In various ways, Caravaggio's figures resist being read only as that which they are meant to represent. This resistance has momentous consequences for his painting since it allows for the ontologically initiatory virtue of his work. It is, however, also occasionally visible as a blockage, or opacity, within the represented scene. In some of his paintings the models have a presence, a visibility that works against their disappearing within the roles assigned to them. For Mancini, as we have seen, the scandal of the *Death of the Virgin* was that "some filthy whore from the slums" is more apparent than the sacred subject she was meant to represent. This is even more strikingly the case with the late *St. John the Baptist* in the Galleria Borghese (1609–10; fig. 5.1). The subject of the painting becomes an oddly old, blasé youth staring at us not to provoke, solicit, or engage us in any way, but rather as if we, and the painter, just happened to be in the line of vision of his impenetrable indifference. The saint's legs are heavy and deathlike; the ram, turning away from the scene (and from us), seems about to disappear into the painting's background; the boy's navel is hidden by the horizontal creases that make the lower part of his torso resemble a crumbling, de-differentiated mass of matter. Only the red drapery spread over the seat on which the youth is posing has any volume. It is the secondary, the purely conventional that has what life

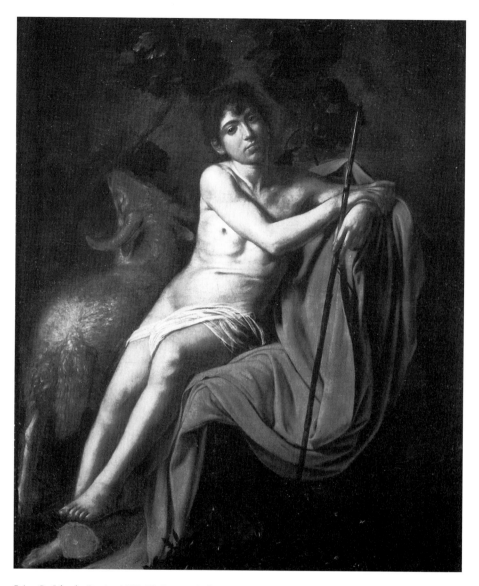

5.1 *St. John the Baptist,* 1609–10. Rome, Galleria Borghese.

there is in the painting, although it is not the life of transferred energy we noted in the raised red curtain of the *Death of the Virgin*. Here the boy himself is too visibly alive, or rather too emphatic in his deadness. Perhaps nowhere in Caravaggio do we have a greater sense of the model having been posed—and of the meaning of the pose having evaporated in the model's very acquiescence in it.

Poses immobilize, but they also raise the possibility of a response the painter might have to take into account. In the representations of an erotic soliciting that we looked at earlier, that response becomes the work's subject. The enigmatic and provocative look may have been initiated by the model as a kind of playfully perverse resistance to the painter. Nothing could be more alien to Caravaggio's art than the ancient method referred to by Alberti: no figure in the painting looks beyond it at "me" (the painter or the viewer.) As Marin points out in his discussion of Poussin's *Arcadian Shepherds*, the French painter found this method wholly congenial: "the illusion [within the painting] . . . does not reach out to me in order to capture or seduce me." This is, of course, what Caravaggio's "illusions" do, a fact that may help to explain Poussin's distaste for him. The seductive reaching out to the painter and the viewer makes impossible the mode of behavior which, as Marin writes, Poussin dictated to his viewers, behavior that can be adequately summarized in a single word: "Read."[1] A subject has been represented which can be contemplated and appraised dispassionately. Not being in the painting, we can judge its adequacy to the reality or the idea it "imitates." The picture's subject is, in its original form, already in the viewer's mind. The anteriority of the subject to its representation gives to viewers a considerable advantage in their confrontation with the work of art. Appreciation and judgment are the logical reception categories in an aesthetic that takes for granted an informed viewer's access to the model that art imitates. To become properly informed may be an arduous task, but it takes place before we come into contact with the work. If realism requires that we, as viewers, educate ourselves in order to earn our position of superiority, the work itself demands nothing of us except that we be its dispassionate judges. It doesn't look out at us, it doesn't call to us; it awaits our verdict.

Caravaggio appears intent on forestalling such judgments by making of the work itself another viewer. Not only are there all the looks, poses, and expressions that enigmatically solicit our attention, depriving us of the spectatorial luxury of a space outside the painting occupied only by an undisturbed, contemplative viewer; the engaged viewer, as we shall presently see in more detail, is also frequently incorporated into the work as a witness of its subject, thereby explicitly making of the relation between the painting and the viewer that which the painting itself performs. Thus, a certain activity on the part of the work's subject prevents it from being defined or identified merely as a subject. The work's meaning is what happens at the moment of an engagement—an engagement between the work and the viewer, between the painter and his models, and between the painter and the subject he sets out to treat. This engagement is not without a certain violence. It is a violence prefigured in the painter's material preparation for his work, in the grinding of his pigments into a fine powder (an activity that Derek Jarman, interestingly, shows repeatedly in his film *Caravaggio*). In painting, matter is pulverized in order to become a signifying material. In his relation to his subjects, Caravaggio performs an analogous act of reidentification. We might also say that his models are ground into meaning, a meaning produced in part by their own participation in the destructive process. The model's reactive physicality always risks pulverizing the role he or she has been told to assume. One of the richest examples of this complex and productive antagonism between the painter, his materials, his subject, his model, and his viewer is the Capitoline version of *St. John the Baptist with a Ram*, a work we will later be examining as a major example of Caravaggio's move from historical representation to ontological projection. In the later Galleria Borghese version of the same subject, the model's emphatic inertness blocks both his identification as an adequate stand-in for St. John and what might have been a collaborative role in a process of *re*identification.

And yet the very immobilization that blocks a transfer of registers (from the historical to the ontological) also produces one of Caravaggio's most powerful moments of social consciousness. It would be anachronistic for us to speak of the model's prominence here as a social "protest," and yet, in a perhaps unin-

tentionally subversive way, Caravaggio, in allowing his model to play his role unpersuasively, also gives him the freedom to resist his assigned function in the production of art. Instead of St. John devoured by his ascetic passion, we recognize a boy of the streets, already gone to seed, in what must have been an uncomfortably contorted pose. Over the centuries Caravaggio has been both criticized and admired for his emphasis on the humble origins of those figures from the Gospel who were to become sacred icons of the Church. This is his "realism," and his presumed sympathy for populist trends in the Counter-Reformation. But instead of humanizing John by compelling us to see in him a man of the people, the model for the late *St. John the Baptist* nearly eliminates the saint from the painting by the force of his own physical personality. He is indifferently available, ready for anything, but this massive indifference itself can be read as an inarticulate protest against his representational *use*. The opacity of his deteriorating flesh is also the resistance of a contemporary body to a veritable industry of symbolization. He'll do anything, but he won't let us forget that that's all he's doing: agreeing, without interest and without rebellion, to do as he has been told. There is an enormous if only potential political explosiveness in this represented refusal, on the model's part, to be an image for anything else, to play a role that might allow his own miserable life not to be seen. To insist so uncompromisingly on his own corrupted being is almost to proclaim the dignity of his seediness. And there we have the unattractive, the unpropitious beginnings of a revolutionary consciousness, far more dangerous than "a sympathy for the people" (officially sanctioned by the Church). Caravaggio allows his model to persist in a disturbing presentness that defeats Caravaggio's own attempt to impose, however provisionally, another identity on him.

A similar effect is obtained in a very different painting from the same period: Caravaggio's *Portrait of Alof de Wignacourt, Grand Master of the Knights of Malta, with a Page* (c. 1608; fig. 5.2, now in the Louvre). Caravaggio has managed both to center Wignacourt and to make him nearly insignificant. His eyes are focused on some distant view outside the painting, to his left. His gaze passes above the head of the young squire accompanying him, who is carrying the Grand Master's helmet and outer garment and who is also looking beyond the

5.2 *Portrait of Alof de Wignacourt, Grand Master of the Knights of Malta, with a Page,* c. 1608. Paris, Louvre.

painting, at the painter (or the viewer). Our gaze is drawn to the boy, who is looking at us as if to question our looking at the painting's main subject, of which, however, he is himself a part. There to emphasize Wignacourt's importance, the boy nearly does away with it by decentering our gaze and relegating the Grand Master to the periphery of our vision. The great attention Caravaggio has given to Wignacourt's armor has the peculiar—unintended?—effect of making him look like a metal puppet. His legs in particular have the grotesque look of awkwardly soldered sections of metal. This aristocrat is all armor, without a body. That Wignacourt is wearing armor is in itself unremarkable. It is the squire who transforms ordinariness into a satirical comment on the relation between the armor and the person. His ambiguous look demystifies the subject of power, raises the possibility of considering social class itself as an armory rather than as a human group. That is the connivance between him and us (a connivance the painter has also allowed the squire to have with *him*). There is a knowledge between us that makes it perhaps superfluous to look at the one who has posed as the center of the painting. With an effect similar to that of the model's indifferent yet emphatic self-presentation in the late *St. John the Baptist*, the squire, unobserved by his master, partially hidden from him by the very trappings of power he is carrying, implicitly invites us to recognize that the center might not deserve our look. That recognition could be the first stage of a militant class consciousness.[2]

Caravaggio is, however, even more ambitious than that. In his most successful work, the process of reidentification actually does take place. Subjects are called forth in order to be ground up: Caravaggio paints the modes of being that his subjects conceal, exposing the inadequacy of purely historical identifications. Take the subject of the betrayal of Christ. The story is familiar: by his treacherous kiss Judas designates Jesus to the soldiers who will arrest him. What would it mean to be faithful to this story of betrayal? And how might we recognize and judge the "truth" of Caravaggio's representation?

These questions are, strictly speaking, unanswerable: there is no original version of the subject. The only way in which a painting could treat "the betrayal of Christ" mimetically would be to imitate compositional *rules of imitation*. The dependence of the one on the other can be seen in Alberti's treatise *On Painting*. Painting, he writes, "possesses a truly divine power in that not only does it make the absent present (as they say of friendship), but it also represents the dead to the living many centuries later, so that they are recognized by spectators with pleasure and deep admiration for the artist." In historical or mythical painting, the spectator's recognition obviously can't depend on a comparison of the work with its model. The accuracy of the painter's representation of an invisible subject will be judged on the basis of how well he paints "visible things." Only by

studying "how in fact things are seen"—how we see each thing in its particular space, in the relations among its several surfaces, and in the colors of those surfaces—will he be able to convince us of his powers of observation. There is a repertory of representational techniques that, once mastered, guarantee the truth of the painter's rendering of *any* subject or idea. This means knowledge not only of such things as laws of perspective or "the reception of light" on surfaces, but also of the correspondences between emotions and bodily signs. "When we are happy and gay, our movements are free and pleasing in their inflexions," while "in those who mourn, the brow is weighed down, the neck bent, and every part of their body droops as though weary and past care." We recognize what we can read; representational accuracy can be inferred from representational intelligibility. For Alberti, the spectator's recognition expresses itself as another imitation. The truthfulness of the representation incites a wish to participate in the scene represented. "Nature provides—and there is nothing to be found more rapacious of her like than she [*qua nihil sui similium rapacius invenire potest*]—that we mourn with the mourners, laugh with those who laugh, and grieve with the grief-stricken."[1] The spectator's imitation of the painting's action testifies to the painter's mimetic talent. The "anteriority" fundamental to realism is not the original time when the work's subject presumably took place, but rather the time of the spectator's experience which he or she repeats (imitates) by participating in (imitating) the painted scene.

This mimetic play of mirrors is, however, subordinated to prescriptions designed to enhance the spectator's appreciation of the aesthetic medium itself. Alberti is the first to claim for painting the status of a liberal art on the same level of achievement and distinction as, for example, music and architecture, and there are rules to follow if painting is to maintain the "dignity" now being claimed for it. The viewer's mimetic participation in the work's subject would have to be suspended so that he can place himself at the distance necessary for a dispassionate appreciation of the painting's aesthetic quality. The painter, Alberti writes, must "be attentive not only to the likeness of things, but also and especially [*in primus*] to beauty." If the ancient painter Demetrius never reached the height of fame, it was "because he was more devoted to representing the likeness of things

than to beauty." Resemblance stimulates our mimetic "rapaciousness," thereby risking to collapse the difference between the painting and the viewer. Beauty, however, restores the distance between subject and object; it is the attribute by which painting earns the right to be classified as a liberal art. Painting can be beautiful only if it maintains its *dignitas*, which is not necessarily identical to imitative accuracy. Thus, according to Alberti, "*there will be no 'historia' so rich in variety of things that nine or ten men cannot worthily perform it*" (emphasis in original). To increase our pleasure, these figures should be given the greatest possible variety of physical positions (some standing, others seated; some in profile, others directly facing us). In works requiring partial nudity, not only "the obscene parts of the body" but also "all those that are not very pleasing to look at" should be covered by clothing, some leaves or a hand.[2] No two figures, finally, should have the same gesture or attitude. Painting has something like its own grammar, which preexists the choice of a particular subject. In order for a painting to be "agreeable," and to be judged "beautiful," it must adhere to the code that defines what it is. The painter's imitation of nature—of the real—will, then, always be selective, and his choices will be guided by the nature of the medium itself. For Alberti, beauty in painting is the effect of a rhetorical discipline.[3]

Finally, we might say that while viewers' mimetic participation in the work and their appreciation of the work's beauty are different moments in a phenomenology of spectator response, they are both determined by the same discipline. The grammar of painting includes not only the prescription covering the maximum number of figures compatible with the work's "dignity," but also the laws of perspective and the visual vocabulary of human emotions. Resemblance *and* beauty are resources of painting. Mimesis, like beauty, is not the effect of an unmediated exposure to a subject. The subject designates the page of the code to be read, and beauty, as well as a persuasive imitation, are the consequence of the skill with which the painter has learned, read, and applied the code.[4]

We cannot say to what extent, if at all, Caravaggio reflected theoretically on these issues. What we know of his working habits—mainly from seventeenth-century criticism of them—does, however, suggest a radical departure from both the procedures and the aesthetic ideal proposed by Alberti. Painting

directly from his models, without the intermediary stage of preparatory draw-
ings, Caravaggio, in a sense, never turned away from his subject (although the
model's physical reality could at times block the painter's perception of his model
as a mirror of his subject). Caravaggio skipped the stage at which, in his drawings,
the painter might consult the grammar of painting in order to test the transmissi-
bility to this particular work of, say, certain combinative guidelines for grouping
human figures or the prescribed code of bodily signs for the emotions of his
historia. Caravaggio's pulverizing, or betrayal, of his subject is identical to his
being invaded by (his models' representation of) his subject. The *Betrayal of
Christ* (1602; fig. 6.1) at once adheres to its subject by means of its visual narra-
tive, and effects the ontological reidentification of that subject. Even more: in
this extraordinary work, Caravaggio represents the reidentifying process itself,
the very gesture by which he betrays his subject.

 With Judas's kiss, Christ can no longer be concealed among his disciples.
Judas moves Christ from the shadows into the light. His betrayal is a kind of
lighting up of Christ's presence; it makes him, among his disciples, uniquely
visible to the soldiers. The identity between the treacherous kiss and a treacher-
ous light is itself made visible in Caravaggio's painting by a figure at the extreme
right who appears to be looking intently, over the soldiers' helmets, at the scene
of betrayal, and who, as if to illuminate that scene better, is holding at the end
of his outstretched arm a lighted lantern. The incident is, then, being viewed by
someone who doesn't seem to be one of the soldiers, by someone whose only
discernible identity is that of a witness. And witnessing here is figured as an
illumination, a spectatorial lighting up of the scene analogous to Judas's treacher-
ous "lighting up" of Jesus as the one accused of being the self-proclaimed
Messiah.

 The witness is at once contemplating and participating in a scene of great
agitation. Caravaggio paints a rush toward the left, a movement stopped or coun-
tered only by the static, resigned figure of Christ and the flying canopy of the
red cape just above his and Judas's heads. Curiously, this movement toward the
left continues beyond Christ, even extends outside the painting in the invisible
section of the left arm of the figure just behind Christ. Narratively, we might

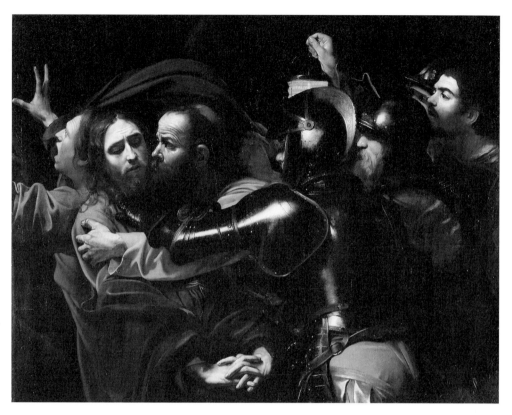

6.1 *The Betrayal of Christ,* 1602. Dublin, National Gallery of Ireland. (Also plate 6.)

understand that figure to be one of the disciples, or the anonymous follower referred to in the Gospel of St. Mark, rushing away in terror from the scene of Christ's arrest.[5] But Caravaggio has made his identity much more ambiguous than that. First of all, is he rushing in horror from the scene we see, or are his arms raised to stop some *other* violent movement about to invade the painting from the outside left? He raises the possibility of a symmetrical invisible violence moving toward the right, a kind of double of the represented violence. The figure himself is, in some ways, a double of Christ. He seems to be a growth on Christ's body. They have identical hair, and they seem to be attached at the head like Siamese twins. The lower part of the youth's body fades into Christ's lower back, and they are wearing similarly colored capes. It is as if the nonresistant Christ were also running away, rushing out from his own head to escape his imminent death only, perhaps, to meet that predestined, inescapable fate also rushing toward him from the opposite direction.

This is peculiar, but narratively intelligible: Caravaggio would have made visible in that figure Christ's terrified humanity; he would have personified the secret wish to escape otherwise manifested only in Jesus' brief cry on the Cross: "My God, my God, why have you forsaken me?" (Mark 15:34). But this reading seems less persuasive when we note that same figure's coupling with the witness at the extreme right. Both are staring intently toward the left with open mouths; both have raised their right arms. Even more: both are doubled. Just to the witness's right there is a helmeted figure almost completely hidden from view. We see part of his helmet and the upper left part of his face. He seems to be viewing the betrayal scene from a position very much like that of his more visible partner, and while he is the least prominent figure in the entire painting, the hand holding the lantern could be his. Compounding this confusion of identities are the functional and compositional similarities between the witness and Judas—both in profile, staring intently toward Jesus, both "lighting up" the figure of Christ. Finally, there is an even more unexpected similarity between Christ and the witness. They are the two most brightly lighted figures in the painting, and the source of the light is in both cases doubtful or even physically unaccounted for. The illuminating effect of the lantern is ambiguous: we might have expected it

to shed more light on the two hands holding the cape or on the back of Judas's head, especially since it may be reaching even further in the opposite direction to cast a strong light on the witness's face. Or perhaps it is not the source of that light; its presence is, in any case, remarkably perverse in a work with so many sharply lit areas—for example, the face of Christ's double, Christ's hands, the trousers of the soldier in the foreground—for which the lantern is obviously not the source of illumination.[6]

The *Betrayal of Christ* exemplifies Caravaggio's failure, frequently noted, to indicate the physical sources of his light. Caravaggio's lighting designates a removal of the physical from laws governing the physical world. It is not at all a denial of physicality, but it does represent the physical as organized and illuminated by being rather than by measurable space. In the *Betrayal of Christ* this means a mysterious rapprochement between the object and the witness of aggression. A light is being held to the witness—but by whom? We have so far neglected to note what is perhaps the most salient characteristic of the witness's gesture: it resembles the painter's outstretched arm and (except for the narrative anomaly this implies) might just as well be extending a brush as a lantern.[7] It is as if Caravaggio had exposed—had "betrayed"—himself staring, avidly yet dispassionately, at his subject of betrayal; betrayed himself by painting himself or his double, not at the distance and the angle from which the scene could actually be represented, but as a contemplative participant in the rush toward the left, looking at it and implicated in it, implicated by virtue of a certain kind of looking. Caravaggio loses sight of his subject by looking with a physical curiosity, a curiosity not about the "meaning" of betrayal but one felt by his body as he paints betrayal, a curiosity about the space of betrayal. Caravaggio puts himself within the painting not in order to get closer to his historical subject but rather in order to see himself both illuminating and experiencing congested space.

The *Betrayal of Christ* makes visible a certain kind of relationality, one in which only a receptive passivity can give direction to and identify a violent onslaught. Christ is the object of a destructive rush. Even in fleeing from himself, he is menaced by a symmetrical onslaught from the left, outside the painting, one that risks crushing him back into himself. The aggression can only be re-

peated, even where we can't see it, because this is the configuration of being the painting represents. We are not in historical time, where there is always a possible or at least imaginable escape from what threatens to crush us. Here there is no escape because what is illuminated is space as crushing movement—and nothing else. Is Judas about to kiss Christ, or has he already kissed him? This question is unanswerable because in the "region" of huddled violence Caravaggio has painted there are no temporal sequences, no before or after—just as there are no locatable identities. More exactly, we should reidentify the narrative figure of Christ as a function within a particular constellation of contacts and positionings. He receives. This function is distributed and differentiated within the painting's space as: (1) the resigned but somewhat self-protective passivity of Christ; (2) the panicky resistance of his double, whose outstretched arms leave him more open to an onslaught than Christ who, with his slightly averted face and crossed hands, at once accepts and blocks the violence rushing toward him with a motionless yet locked-in body; and (3) the witness's optical reception of that scene *and* of the light that exposes him as simultaneously within the movement and staging it. All of this has never happened before; indeed, it *can* happen only in art.

Art alone initiates the visibility of pure relationality, of being *as* relationality. Modern art has raised the question of whether it is even necessary to include, within the work, the terms of relations. Stanley William Hayter has written that Kandinsky "figures motion as an element itself without invariably representing that which moves or has moved." Frank Stella, who quotes this remark, goes on to speak of Kandinsky's preference for Cézanne over Raphael, a "preference which could be called the principle of weightless composition, [and which] reveals a horror of solid form, a fear of the weight of material objects." The "new freedom" sought by Kandinsky would "dissolve the ground plane of the past into a surface of contiguous weightless relationships."[8] For Caravaggio, as well as for the other artists of his time, relationships could be made visible only through the terms, the weights, that constitute them. In his work, movement and the relations initiated by movement are always embodied in objects and human figures. There is no place where being can be visited and no time when it can be said to have appeared, and yet it can be made present only

in history, on which it depends and which, in art, it displaces.[9] In Caravaggio's work, the betrayal of Christ becomes the site where, for the first time, congested connectedness appears.

Caravaggio's paintings constitute an ontological laboratory. His religious subjects provide the representational material for a repertory of modes of relationality. The de-temporalized physicality of his work creates an austere sensuality, a sensuality of forms. In the *Conversion of St. Paul* (1600–01; fig. 6.2), Paul has been thrown physically so that he may be reoriented spiritually. He is lying on his back under his horse's raised hoof, his arms reaching up presumably toward the divine agent that has chosen this sudden and violent form of conversion. But there is no sign of the supernatural in Caravaggio's painting (as there is, most notably, in Raphael's and Michelangelo's treatments of the same subject), and Paul's arms are raised in order to become, for the viewer, part of the extraordinary jumble of human and animal arms and legs that occupy the center of the work. We are "thrown" by this displacement of the secondary (from a narrative point of view) to an area of primary importance. It is an area at once dense and "empty": this heavily populated (and somewhat confusing) space includes four patches of background space between the groups of limbs. Nothing actually touches anything else, no form impinges on any other form, and yet the curious effect of this juxtaposition of discrete but related forms is to put into question the very possibility of an empty space. A closer analysis of this work would show how those spaces are crossed, and structured, by all the virtual lines linking the elements within the painting's complex system of repetitions and pairings. The effect of a compressed assemblage of forms is intensified by the absence of any depth of field. The movement toward a background space initiated by the diagonal lines of Paul's body is interrupted by the round volumes of the rear half of the horse's body, volumes that resist any perspectival diversion from the painting's crowded frontal center.

The *Conversion of St. Paul* represents the unavoidable connectedness of forms in space, but, unlike the *Betrayal of Christ*, it gives us an *un*congested connectedness, thereby proposing that touch is not indispensable to contact. Caravaggio's Paul may indeed be converted to something, but his gesture upward

6.2 *The Conversion of St. Paul,* 1600–01. Rome, Cerasi Chapel, Santa Maria del Popolo.

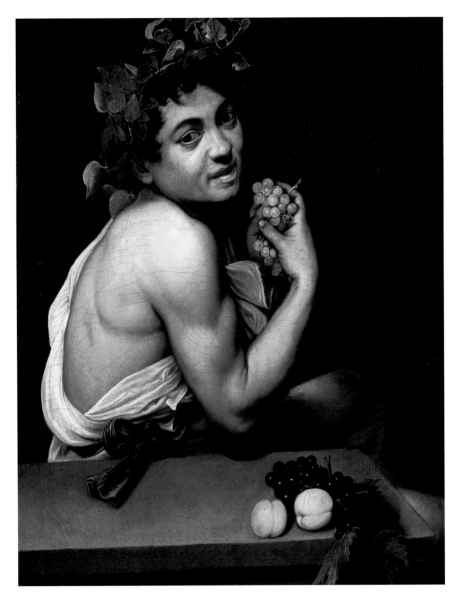

Plate 1 *Bacchino Malato* ("Sick Bacchus"), c. 1593. Rome, Galleria Borghese.

Plate 2 *The Fortune Teller,* 1593–94. Rome, Pinacoteca Capitolina.

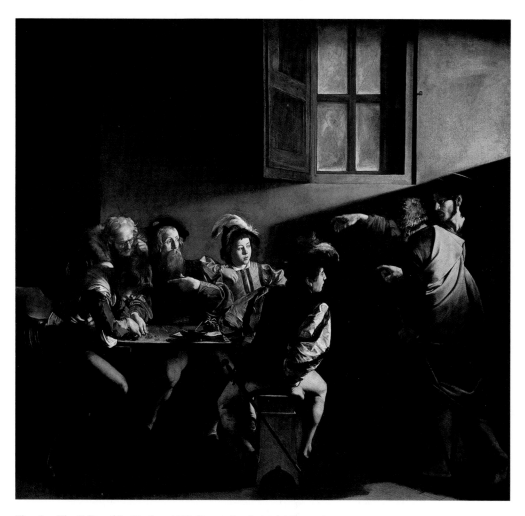

Plate 3 *The Calling of St. Matthew,* 1600. Rome, San Luigi dei Francesi.

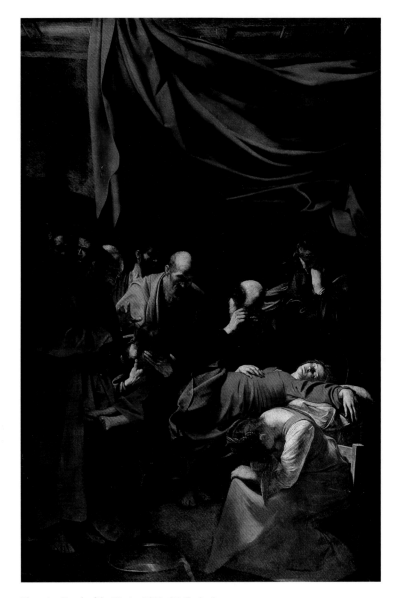

Plate 4 *Death of the Virgin,* 1605–06. Paris, Louvre.

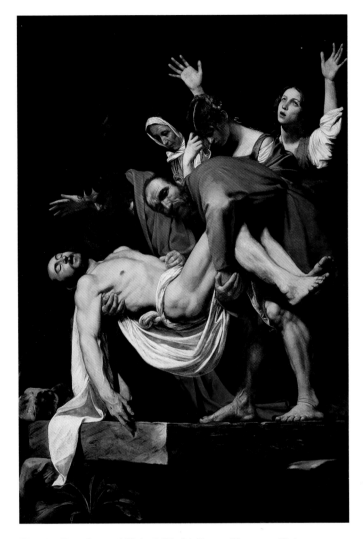

Plate 5 *Entombment of Christ*, 1602–04. Rome, Pinacoteca Vaticana.

Plate 6 *The Betrayal of Christ,* 1602. Dublin, National Gallery of Ireland.

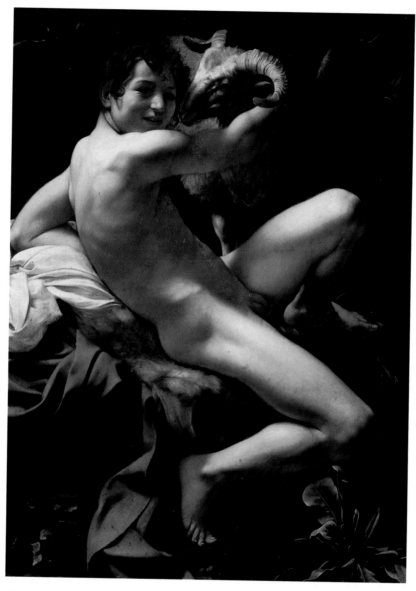

Plate 7 *St. John the Baptist with a Ram,* 1602. Rome, Pinacoteca Capitolina.

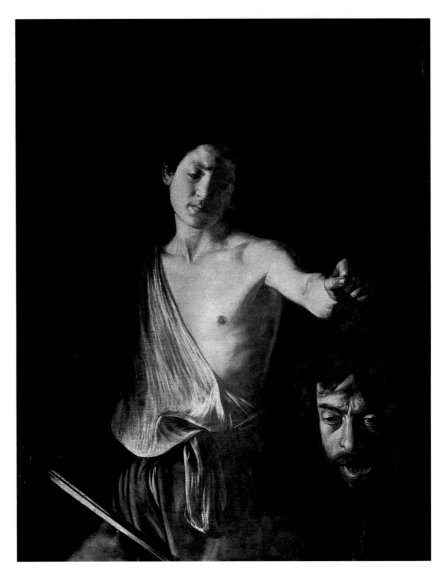

Plate 8 *David with the Head of Goliath,* 1609–10. Rome, Galleria Borghese.

meets only the horse's body; there is nothing above that. Paul "turns toward" a new relatedness, but one without transcendence, a relatedness with the *natural* nonhuman. Paul is lying there in order to "receive" his horse, whose curiously nonthreatening hoof is raised, so it would appear, for no other reason than to have us notice the formal similarity between it and the round bit of clothing between Paul's legs. The hoof is poised, immobilized, not as an imminent blow, or an imminent penetration, but rather as an *appearance*, and Paul's ecstatic passivity might be read as his new receptiveness to the austere sensuality of a universal connectedness of forms.

The spatial bondage of the *Crucifixion of St. Peter*, which like the *Conversion of St. Paul* is in the Cerasi Chapel of Santa Maria del Popolo in Rome (1600–01; fig. 6.3), is strikingly different from the generous openness of that vision. St. Peter, already nailed to his cross, is being raised by three laborers in order to be crucified upside down. Perhaps inspired by the acute consciousness a body has of its own weight in that position, Caravaggio has painted differently positioned weights in space. He is less interested in the distinction between victim and executioners than in various ways of seeking to overcome a strong gravitational pull. The painting is a nightmarish vision of the weight of bodies resisting all efforts to move upward, away from the earth to which our bodies are "nailed," as Peter is nailed to his cross. (Earth is prominently figured by the broken stone and muddy feet in the foreground.) Relationality here is a struggle against mass, a gripping of objects in order to make them responsive to a human will. In marked contrast to all the open hands in Caravaggio's work, the *Crucifixion of St. Peter* is a repertory of closed or clutching hands: the laborer's hand around his shovel, Peter's hand closed in on the nail that has been hammered through it, the other two executioners gripping the wooden cross and the rope they are using to raise it. Caravaggio has positioned the four figures at that moment in the raising of the cross when they themselves take on the shape of a cross, one that is slightly decentered, as if it were rotating to the left. That rotation could be the beginning of a propeller-like movement, but such a possibility appears to be suggested only to make the weights resisting it more prominent.[10] Relationality here is agonized gripping and lifting against a space that does nothing more than press down, that

6.3 *The Crucifixion of St. Peter,* 1600–01. Rome, Cerasi Chapel, Santa Maria del Popolo.

reduces physicality to the brightly painted massive buttocks of the executioner closest to the viewer, whose head has disappeared under the cross and who is nothing but the weight of his tensed legs and arched back. The prominence of that part of this figure's body emphasizes the fantasy at work here: that of the human as a struggle to crucify its own materiality. The only direction in which bodies naturally move here is down, toward their dissolution into dead matter. In this anal mode of spatiality, only the "weight" of an undiverted act of will might preserve the human from being merely that which drops.

The ontological laboratory of Caravaggio's work includes many such models of relationality. From them we may return to history with a new sense of our *options in space*. Put that way, the profit to be drawn from his work un- doubtedly sounds austere and unattractively abstract. But our imagination of other types of options that we might consider more humanly significant— affective, ethical, political options—is probably at least initiated by our physical experience of space. All behavior could be described in terms of connectedness, and the first connectedness we know is physical. Modes of relationality in human life are "deduced from" our perceptions of spatial relations. More exactly, they are imitations of our body's experience of space. This move from the perceptual to the various orders or registers of the psychic is analogous to Freud's descrip- tion of the ego as "that part of the id which has been modified by the direct influence of the external world through the medium of the Pcpt.-CS [Percep- tion-Consciousness]; in a sense it is an extension of the surface-differentiation." Also: "The ego is first and foremost a bodily ego; it is not merely a surface entity, but is itself the projection of a surface."[11] In this account the ego repeats the body's contacts with the world in metaperceptual structures. As a psychic imita- tion of surfaces, the ego architecturalizes the body's moves in the world. Laplanche's recent description of the formation of the unconscious traces an- other trajectory from the perceptual to the psychic. The unconscious "collects" that which the infant can't understand, can't render intelligible through symbol- ization, in its visual contacts with the mother's gaze, its aural contacts with her voice, and its tactile contacts with her nurturing body. A complex set of spatial relations—the meeting of eyes, the proximity of a voice, the enveloping pres-

ence of a cradling body—initiates a structuring division of consciousness. What can be interpreted remains conscious, while the unconscious comes into being in order to preserve and to store that which the conscious mind rejects (in an originary or primal repression): the uninterpretable messages from the space in which the infant lives.

The models of relationality in an art like that of Caravaggio could be thought of as providing the opportunity for a sublimated repetition of the processes described by Freud and Laplanche. Relationality, divorced from its empirical realizations, can now be contemplated—witnessed—rather than submitted to. At the same time, the painter's use of figurative representation puts on display a move in the opposite direction: the insertion of nonhistorical modes of being in time. Thus, the relations revealed by an art unconstrained by the historical circumstances it claims to represent are shown to be historically available. They trace a sensuality, the pleasurable and diversified extensibility of the body in space we may have *missed* in the urgent and exclusionary soliciting of our attention—of our spatial imagination—by the narrow environment that first called us into the world.

BEAUTY'S LIGHT

Caravaggio, we said earlier, looks at the scene of betrayal with a physical curiosity, a curiosity that can be satisfied only if he puts himself in the painting. In the *Betrayal of Christ*, Caravaggio-the-witness at once participates in the rush toward Christ and helps to illuminate that very movement. He shows, and he is part of what is being shown. This might suggest an important distinction between the painter and his double: it is as if the former had added himself to an already constituted scene in order to give himself the pleasure of contemplating his body's participation in the scene. In describing things in this way, we would be maintaining a crucial distance between Caravaggio and his work even as we describe his presence in the work. The painter is half painting subject and half painted object, a split that does not substantively affect the subject-object relation itself. But what if Caravaggio's presence in the painting is meant to invalidate *that* relation? He may, that is to say, be already in the painting before he decides to put himself in it. Only by insisting on this interpretation of what we said earlier will we be able to account for something we have until now failed to address: *how*, exactly, the move is made from the historical to the ontological. Implicit in our earlier discussion of Caravaggio's physical "curiosity about the space of betrayal" was a possibility we now want to look at more closely, one that will correct the dualism too easily consented to in such expressions as "a

curiosity about . . .". There is perhaps no spectacle prior to a certain kind of witnessing. That witnessing produces the spectacle (realizes the move from a relational narrative to relationality itself) that it also contemplates.

The production of light may be the catalytic sign of such moves. A passage from the first volume of Proust's *A la recherche du temps perdu* is exceptionally explicit about art as a kind of illumination. "Combray" is, in large measure, the story of an intellectual adventure. At the end of his account of the summers he spent as a boy at the family home in Combray, the narrator writes: "It is because I believed in things and in people while I walked along those paths [of the Méséglise and Guermantes ways] that the things and the people they made known to me are the only ones that I still take seriously and that still bring me joy."[1] That "belief" expressed itself as a state of excited anticipation. What made the things and the people of his boyhood uniquely real was Marcel's conviction that hidden in them was "the secret of [t]ruth and [b]eauty" (1:91). If he looked hard enough at a flower, if he could speak to the famous writer Bergotte, if he could see the great actress Berma, the secret would surely be revealed. The distinction between the flowers he could visit every day and the great artists it seemed unlikely he would ever meet was less important than the privilege his youth lent to things both known and unknown. The characteristic Proustian posture is that of an anxiously strained attention to the world, whether it be Marcel lost in concentration in front of the hawthorn blossoms or, later in Paris, feverishly expecting to find in Berma's acting "verities pertaining to a world more real than that in which I lived" (1:477).

In Proust the entire world is, potentially, an enigmatic signifier. Nature in "Combray" appears, at certain privileged moments, to address Marcel in a language he can't understand. The address excites him, and he strains to penetrate the secret being simultaneously offered and withheld. At times the world does seem to yield its secret and, as others have noted, this takes the form of a *self-*penetration. Marcel appropriates the object by finding a metaphoric equivalent for it in himself. Knowledge turns out to be an act of creative memory: not the memory of a specific time in his past, but the selection, from a vast store of mnemonic resources, of the term that best "corresponds" to the soliciting exter-

nal object. As Laplanche might put it, the enigmatic signifier is metabolized by a successful symbolization. Laplanche is primarily interested in the failures of the symbolizing process; what becomes clear in Proust is that in this process a certain kind of self-knowledge stands in, so to speak, for knowledge of the world. We are in a relational system entirely dominated by secrets and knowledge. And what is taken to be a successful unveiling of the secret is in fact the establishment, by the subject, of a new relation to himself. Affectively, Marcel moves from a sense of lack or deprivation to a feeling of plenitude. (This is comically expressed when, having written the metaphorically dense passage that presumably captures what the Martinville steeples were offering him, he begins to sing with joyous relief "as though I myself were a hen and had just laid an egg" [1:199], the "egg" of his own descriptive resources which he has finally expressed, pressed out of himself onto the page.) In this system the world, presumed to hold "the secret of truth and beauty," does little more than mediate two relations to the self—one of lack and one of plenitude. We may infer from this that the sense of a precious secret in the world displaces a sense of being cut off, or barred, from some internal secret. We are at a stage subsequent to the intersubjective relation in which the child is excited and threatened by an originary enigmatic signifier. Now the unmetabolized residue of the other's address has become an enigmatic signifier *within* the subject. The predominance of knowledge as a goal within this relational system perhaps makes inevitable the shifting of the secret from the outside to the inside, and the eventual possession of the secret's contents through a self-expansiveness in which the subject, now more than adequately filled, might even dispense entirely with the external spectacle.

Occasionally, however, the effort to penetrate the object's secret reinforces the object's presence. Here is the narrator's description of the buttercups he used to come across during his walks along the Guermantes Way:

> For the buttercups grew past numbering in this spot which they had chosen for their games among the grass, standing singly, in couples, in whole companies, yellow as the yolk of eggs, and glowing with an added lustre, I felt, because, being powerless to consummate with

my palate the pleasure which the sight of them never failed to give me, I would let it accumulate as my eyes ranged over their golden expanse, until it became potent enough to produce an effect of absolute, purposeless beauty. . . . (1:183)

Ils étaient fort nombreux à cet endroit qu'ils avaient choisi pour leurs jeux sur l'herbe, isolés, par couples, par troupes, jaunes comme un jaune d'oeuf, brillant d'autant plus, me semblait-il, que ne pouvant dériver vers aucune velléité de dégustation le plaisir que leur vue me causait, je l'accumulais dans leur surface dorée, jusqu'à ce qu'il devînt assez puissant pour produire de l'inutile beauté. . . .[2]

The characteristic posture of straining toward the object's hidden, precious depths is modified here. Instead of trying to get at what the buttercups may be hiding, Marcel simply has to find a use for his own pleasure. And yet we may conclude from this pleasure (as Marcel himself apparently does) that there is something worth possessing in the flowers. Significantly, their resemblance to egg yolks doesn't stimulate his appetite. Rather, it gives him pleasure, a pleasure which, as he recognizes, can't be directed toward a desire to eat the buttercups. Visual pleasure here—unlike the pleasure of looking at egg yolks—is not simply the promise, the foretaste, of a gustatory pleasure. But the "incorrect" analogy with eggs has the virtue of blocking Marcel's usual response to the pleasurable excitement that objects—and, at times, the sight of other people—give him: the desire to appropriate them. Here the actual devouring of the object occurs to him and is immediately dismissed. We are far from his most characteristic relation to the external world, which is a devouring one; his metaphors generally function as sublimated incorporations. They "solve" the mystery of otherness by digesting it; objects become the pretext for a lavish display of Marcel's internal "system." In the buttercups passage, such appropriations are forestalled by an image from that very system: the egg yolks that bring Marcel back to the mystery of the *flowers'* capacity to give him pleasure.

What happens then overturns the entire epistemological scheme we have been describing. Unable to prolong and to consummate his pleasure by shifting

it from one sense to another (from sight to taste), Marcel projects it back onto its cause. His pleasure thus becomes visible in the buttercups that were its source, and it is this visibility of the flowers' effect on him that produces "beauty." Once rendered visible in this way, his pleasure can't be dissipated (as the pleasure of eating is dissipated by satiety); it merely "accumulates," and beyond a certain threshold of "potency" it transforms the golden surface on which it has been posed into an object of art. Indeed, the passage proposes a genealogy of art that, for the most part, remains implicit, theoretically unexplored in *A la recherche*. Here we see an aestheticizing of ordinary objects as a result of a perceptible intensification of the pleasure they have given us.

Interestingly, beauty is at once grounded in appetite and wholly independent of it. The buttercups would perhaps not have lent themselves to the aestheticizing process if there had not been, at the beginning of the process, a momentary confusion between them and something that can be eaten. But the appetitive relation disappears, although its disappearance may depend on a frank recognition of the continuity between it and the aesthetic. It is when the desire to incorporate is disguised as a longing to penetrate "the secret of truth and beauty" that it persists within that longing as an appropriative relation to the world. Philosophy and art, however intellectually and formally elaborate they may be, then perpetuate the myth of a detached subject intent on understanding what is different from it. The reality behind that myth is a sadistic subject intent on preserving its own integrity, its own presumed autonomy, and, as we suggested a moment ago, destroying what is different from it. An erotic thrill undoubtedly accompanies the (imaginary) success of this project; it is the thrill of a hyperbolic ego expanding beyond the boundaries to which its constitutive relation to bodily boundaries would seem to have assigned it.

Nothing could be more different from this sadistic movement toward objects in order to appropriate them than the generous self-projection of the buttercups passage. Appetite initiates the process, but is immediately recognized as futile. These extraordinary lines encapsulate in extremely dense fashion what is undoubtedly a long, difficult and perhaps rarely successful apprenticeship in a *non*sadistic relation to external reality. The egg yolks analogy is somewhat comical, and trivial, but it catches perfectly what is after all the comical and trivial

nature of the appropriative project: the illusion that the ego can incorporate its environment. This illusion is ennobled and sublimated as the desire to under-stand, and we call the fruits of invasive appropriation "knowledge." Generally, Marcel is exasperated at not being able to know the secrets buried in objects and other people. Here, the incorporative project is seen as useless, and this judgment helps to delineate a deceptively familiar notion of beauty. Uselessness is itself sublimated: from a recognition of the irrelevance of the desire to eat to the plea-sure the flowers give him, to a removal of the flowers from any utilitarian func-tion and their promotion to the status of aesthetic objects of which no use can be made.

As a result of their uselessness, the buttercups can be looked at with disin-terest. But if this passage from Proust implicitly defends a traditional notion of disinterest as crucial to the aesthetic response, it does so, not by reinforcing the distinction between the viewer and the object, but rather by proposing a form of connectedness consistent with disinterested contemplation or witnessing. Compared with the pseudo-detachment of an appropriative subject intent on absorbing and eliminating difference, the experience described in the buttercups passage may seem to be one of inviolable distance between subject and object. We should, however, remember that the object's beauty is the effect of Marcel's pleasure *on* the flowers. Beauty, then, is a mode of relationality, a manifestation of the subject's implication in the world. Marcel's pleasure enhances the object's independence, its difference from Marcel. The flowers shine in their own being as a result of Marcel's pleasure being lent to them. Their golden surface becomes brighter and brighter until, it would seem, there is a change of ontological regis-ter. More precisely, the buttercups are transferred from nature to art through their emphatic, illuminated appearance *as* buttercups. And it is Marcel's pleasure that moves them from the natural world to the world of art, although the natural world is never left. There is a certain violence to this move, the violence of Marcel's attentive presence coercing the flowers to *be* themselves, which, as the subsequent lines of this passage indicate, includes the "modest horizon" of the French countryside in which they now grow and "un poétique éclat d'orient" that evokes their home, many centuries ago, in Asia. The integrity of the butter-

cups as buttercups is identical to Marcel's narcissistic pleasure as he watches the flowers glow into their own being as a result of his having placed *his* being on their surface. Through his pleasure he "corresponds" with and to that which is at once different and identical to himself—a segment of the world's appearance.

Analogously, in Caravaggio's *Betrayal of Christ*, it is the witness who illuminates the scene as the appearance of a certain form of relationality. His face is lighted as brightly as that of Christ, which suggests that what the painting brings into the open, what it "unconceals," is *his* bringing "the betrayal of Christ" into unconcealment.[3] What we have called the work's congested connectedness is *the form of the witness's looking*. And what is undoubtedly most difficult to understand about this is the necessity of the witness *within* the scene that is unveiled or illuminated. He is not there simply to indicate that there would be no scene if there were not someone to look at it; he is there to show that even when—unlike in this painting and the passage from Proust we have been considering—the writer is not represented, the being unveiled in art (the being on which, as in the *Death of the Virgin*, the curtain is raised) is always a relation realized by the subject's implication in it. Relational being is constituted by and as a subject position. This doesn't mean that being is subjective; indeed, the very distinction between subjective and objective is meaningless here. What Caravaggio paints in the *Betrayal of Christ* removes us from history and has the generality of a *type* of relationality; but the type itself is constituted by a subject's active participation in it. In other terms, being always happens; it is not something to which a subject of superior intelligence would have reflective or contemplative access. The artist enters his subject as its constitutive relational term. In so doing, he is not "expressing himself." Rather, he makes visible (or intelligible or audible) a subject's compositional activity in the universe, thereby confirming or refiguring his audience's—and his culture's—relational habits.

In this view, art is a universal activity. If sequestering this activity in the specialized domain of aesthetic production has the disadvantage of suggesting that the participation in relational being is a rare privilege or gift, it also has the great advantage of offering that participation as a spectacle unobscured by the exigencies and the opportunities for appropriative profit in historical circum-

stances. That is, art illuminates relationality by provisionally, and heuristically, immobilizing relations. A light we never see appears, as being, momentarily "trapped," designates itself to us. In the *Betrayal of Christ*, that designation is itself designated by the prominent strip of light on the armor covering the out-stretched arm of the soldier reaching toward Jesus, a light that has no function other than to make illumination literally the center of the painting. Beauty is illuminated being.

In the aesthetic we are outlining (and which, it seems to us, Caravaggio's work proposes), art does not restore a fantasmatic wholeness. Proust is torn be-tween these two possibilities: art as appropriating the secrets of truth and beauty without which the subject is incomplete, and art as the demonstration of an active insertion into the movement of being. The first of these alternatives is an aesthetic—and an epistemology—grounded in fantasies of castration. Only the second alternative can cure us of the first, for it "proves" that there are no gaps, no empty spaces, in creation. We are not *cut off* from anything; nothing escapes connectedness, the play of and between forms. Because of its confirmation of this severe and exhilarating law, perhaps only an aesthetic of the sort practiced by Caravaggio, one conceived of as the discipline of relationality, can relieve us of the anxiety of castration—not because such an art satisfies our appetite for possession, but because it demolishes the very distinction between subject and object which sustains that appetite. Truth is the appearance of being—the re-splendence of Proust's buttercups, Caravaggio's illuminated relationality—rather than a conceptualizable secret of being. In a sense, there is nothing "to know," only the consciousness of the movement in which we participate.

Caravaggio's art owes nothing to an aesthetic of imitation. His work is clearly not intended to compete with nature (his awkward rendering of spatial depth, his failure to account for realistic sources of light testify to his indifference to any such rivalry); nor does his work suggest an interest in an idealized imita-tion of nature, one that might render nature free of the imperfections inconsis-tent with what Alberti called art's *dignitas*. (Most ambitiously, such an imitation seeks to reveal the objective laws of nature through a mimetic translation of the universal principles immanent to phenomena but generally invisible to us.) In all

the versions of pictorial mimesis, the main participation of the artist (and the viewer) in the work risks being one of confused apprehension: the work is so much like the object it imitates that we may confuse it with "the real thing." The participation to which such works as the *Betrayal of Christ* invite us has nothing to do with any such confusion. The representation is not measured against its model. Caravaggio's relation to his models (both his subjects and the figures who posed for him) seems to have been, as he painted, a kind of bodily projection into relations at once discovered and initiated by that very projection. Hence the appropriateness of his failure to paint from preliminary designs. Whatever other value such designs may have for an artist, they can also operate as a defense against the physical imagination we have been describing. The design disciplines, even dictates the painter's moves; it frames the final representation (defining its limits) before the activity of that representation has even begun. The design helps the painter to "get it right," thus serving, in yet another way, his illusion of himself as removed from his subject and as having the epistemological obligations and privileges conferred by this distance.

Caravaggio, we stated earlier, is an important figure in the history of a suspicion that truth cannot be the object of knowledge. The very concept of knowledge is irrelevant to the truth of being that Caravaggio's work makes appear. We should perhaps even reformulate this, eliminating the reference to truth, which has been conceptually too dependent on knowledge: truth, after all, is something we seek to know. When art stops pretending to serve this philosophical prejudice, it demonstrates the inadequacy of knowledge as a category capable of containing the modes of relationality. Caravaggio's critique of the relational system limited by an obsession with knowledge takes place, we have been arguing, through a movement away from the erotic secret as the principal object of human looking. The erotically soliciting gaze narrows and centers our look; in this sense it is functionally similar not only to Christ's imperious look in the *Calling of St. Matthew* but, more generally, to any system of belief that claims the right to center our visual and spiritual attention, to be the primary object of passionate interest.

———

Beyond—or Before?—Sex

In modern literature, the critique of knowledge as determining the dominant relational system has been made most powerfully by Flaubert. Of particular interest to us is the fact that Flaubert proposes, as an alternative to that system, a spatial sensuality similar to the experience of space given to us by Caravaggio's painting. An indication of how unfamiliar our culture has made that alternative to us is the difficulty readers of Flaubert have had in defining the interest of his work, or his "greatness." It is as if we intuitively recognize his importance without being quite secure about the reasons for it.

The most obvious fact of Flaubert's fiction, which early readers made a great deal of, should be emphasized once again: his characters are usually stupid or ignorant (Emma Bovary, and Félicité of "Un Coeur simple," in particular) or, at best, extremely ordinary (Frédéric Moreau of *L'Education sentimentale*). Critics at first handled this by finding compensatory virtues in all these mediocre figures. The illiterate, inarticulate, comically ignorant Félicité thus has a heart of gold; Emma, for all her intellectual and sentimental mediocrity, at least aspires to something more refined (if only materially more refined) than the stifling provincial bourgeois world of her husband and Homais. Her very real suffering somehow redeems her equally real callousness and the triteness of her dreams of love inspired by third-rate romantic literature. Most contemporary critics are too

sophisticated for such realistic psychological defenses. Today we read such dull stories as "Un Coeur simple" for Flaubert's style, or for the "silences" in his work, when the troublingly mediocre characters disappear and we thrill to the monotony of a subjectless, neutral linguistic murmur. Such readings, however intellectually interesting, may nonetheless be missing something even more original. Henry James, who could not be accused of a lack of sophistication, didn't hesitate to complain about the mediocrity of consciousness in Flaubert's protagonists. Emma, he complained, "is really too small an affair"; it must have been "a defect of [Flaubert's] mind" that led him "to imagine nothing better for his purpose than [Emma Bovary and Frédéric Moreau], both such limited reflectors and registers."[1] Suppose, following James's example, we try being bothered once again by Emma's mediocrity—to the point of not allowing ourselves to be diverted from it by her presumed absorption, and convenient disappearance, in the images and cadences of Flaubert's style. We might then be forced to see that her stupidity is the precondition for her originality and that, like Félicité, Frédéric, and Bouvard and Pécuchet, she is the perfectly adequate vessel for Flaubert's devaluing of knowledge and even, in a certain sense, of intelligence.

The nineteenth-century critic Ferdinand Brunetière was the first to speak of Emma's *finesse des sens*, by which he meant her acute receptivity to all sensory experience.[2] Literature corrupts this sensuality. It is not so much (although this is true) that the books she reads renders her unfit for the life into which she was born and which she can't realistically hope to escape. Nor is the novel's originality exhausted by Flaubert's managing, contrary to James's impression, to make Emma's life stand for the seductively dangerous unreality of imagination itself, for the incommensurability between the limits of experience and the limitless wandering of the linguistic imaginary. There is something else: the novels she reads train Emma to think that her senses can be satisfied only by love. Her *body* is crippled by a reduction of the sensual to the sexual. Thus we often see her unreflectively sensualizing all her contacts with the world only to insist, against the evidence of her richly diffuse pleasures, that only sexual love can legitimately solicit her body. There is no such "mistake" on the part of Félicité; she is nothing but the diffuse receptiveness that Emma distorts by reducing it to a narrative

of sexual romance. Félicité's affective vulnerability is only one part of this re-
ceptiveness. The story of her life nearly disappears in the descriptive envelope of
the multiple sources of her sensations. Her exploitation by all those who become
the object of her devotion is the pathos of a nearly unqualified penetrability. She
is selfless not merely in relation to those to whom she sacrifices herself but also,
in a more original fashion, in her relation to nature itself. She is nothing but
communication, in the strong sense Bataille gives to that word, the sense of a
continuity of being in which individuality dies. Félicité's generosity is, funda-
mentally, impersonal; it is the continuously renewed correspondence between
her person and the stimuli that solicit her to leave her identity as a person. In
this sense she realizes Flaubert's own ideal of aesthetic impersonality, an ideal
that seems to have required not so much an intellectually disciplined effort to
imagine otherness, as a sensual capacity to become the corporeality of the other.
Félicité is perhaps even superior to her creator, since Flaubert's literary vocation
(the demands of which he never ceased to agonize about) presupposed a con-
sciousness of the need to translate that sensuality into language. This con-
sciousness necessarily became, as Flaubert's letters repeatedly illustrate, a self-
consciousness that could only block the very fusions it sought to produce.

In his fiction Flaubert becomes a witness to the projective sensuality that
defines the originality of such figures as Emma and Félicité. And his witnessing
is itself a complex event. He documents, first of all, the incommensurability
between a connectedness to the universe he was one of the first to make explicit
in literature (he made it a subject) and the narrowly focused relationality of the
society he knew. There is, however, nothing in his work that suggests how Em-
ma's sensuality might become socially viable, how it might nourish or even in-
spire new definitions of community. Also, perhaps because in his own case that
sensuality was inseparable from a literary intelligence that at once cultivated and
suppressed it, Flaubert tended, prejudicially, to associate the impersonal narcis-
sism of such figures as Emma and Félicité with stupidity. Thus, Emma's ideas are
as cliché-ridden as those of Homais, a resemblance that obscures the enormous
difference between his hyperbolically defended ego and the self-leakages
through which Emma ceases even to be an ego and begins to move, to flow with

the sources of her sensations. There is, furthermore, the curiously moralistic tone of Flaubert's description of the priest administering last rites to Emma. The passage is, at the very least, ambiguous, conflating Madame Bovary's diffuse sensuality with adulterous self-indulgence:

> Then he recited the *Miseratur* and the *Indulgentiam*, dipped his right thumb in the oil and began the anointments: first her eyes, which had so fiercely coveted all earthly luxury; then the nostrils, so avid for warm breezes and amorous scents; then her lips, which had opened to speak lies, cry out in pride and moan in lust; then her hands, which had taken such pleasure in sensuous contacts; and finally the soles of her feet, once so swift in hurrying to gratify her desires, and now never to walk again.[3]

There is still, in Flaubert, a commitment to the relational system dominated by knowledge, a commitment that seems to have made it difficult for him to imagine a different kind of intelligence, one whose syntax would map the body's movements and contacts. (This could be the intelligence that Caravaggio's corporeally learned St. Jerome might inscribe once he began to write. . . .)

And yet there is also, in *Madame Bovary*, an uninterrupted stylistic participation in the movements of Emma's real and imaginary body. We are thinking of the narrator's *style indirect libre*, that peculiar point of view which is not a point of view, in which we can locate neither Flaubert nor Emma, in which—like the Caravaggio-witness in the *Betrayal of Christ*—he contemplates her frequently willful yet no less self-annihilating sensual responsiveness by going along with it. He moves with her body, just as Caravaggio's witness is a constitutive element of the bodies rushing to seize Christ. Flaubertian irony is the linguistic equivalent of the light shed by the witness's lantern in the *Betrayal of Christ*. It both illuminates the novelist as an implicated spectator, and yet also suggests, mysteriously, a certain distance within a confusion of being in which there would seem to be no space for distance, a slight but crucial retreat of consciousness that allows for the representation of the confusion.

More decisively than Flaubert, Caravaggio resists the reduction of the sensual to the sexual. We have been studying in his work the move from the erotic—which, with its emphasis on an enigmatic signifier, institutes the unconscious and places a problematic of knowledge at the center of human relations—to another mode of connectedness between bodies. The *Fortune Teller* is an early confrontation between these two systems; the extraordinary *St. John the Baptist with a Ram* (1602; fig. 8.1) in the Capitoline museums in Rome pictorially elaborates upon this nonerotic sensuality *and* suggests, in Caravaggio, a certain anxiety about it. As in the *Fortune Teller*, one figure appears to be intensely looking at another; if the youth in the *Fortune Teller* returns that look with indifference (he is more of an exposed surface than a participant in this visual pseudo-dialogue), St. John turns frankly away from the ram, directing his half-smile toward us. Thus it seems plausible to align him with the *Bacchino Malato* and *Victorious Cupid*, and even to refer to him, as Alfred Moir has, as "a pagan little tease, uncontaminated by Christian sentiment," addressing the viewer with erotic provocation.[4] Indeed, the painting clearly displays the double character we have associated with the erotic address: the nude youth, half-reclining with legs spread and the right arm extending away from us, as if protecting or concealing something from our view. But the effect of provocation, and of an erotic secret, is significantly modulated here. There is, first of all, the gentle intimacy between the boy and the animal. If the extended arm is protecting anything, it is the ram it embraces, a gesture repeated, in the opposite direction, by the ram's head turned toward, almost touching the boy's face. We begin to see the possibility of a new sort of address (or rather, this time, of exchange), one in which the faces do not become readable but where the very gesture of concealment is performed as a physical *contact* rather than as a provocatively isolating move. Furthermore, the contact here is between species; the youth may be turning his head toward us not to address us erotically, but rather in order to draw our attention to his intimacy with the ram. This possibility doesn't in itself make his look less ambiguous: to what, exactly, is it that we are being invited? How is the invitation different from the one the *bacchino* appears to be asking us to accept?

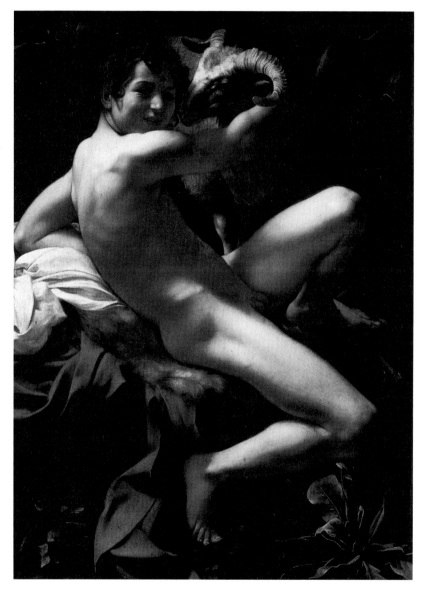

8.1 *St. John the Baptist with a Ram,* 1602. Rome, Pinacoteca Capitolina. (Also plate 7.)

The answer lies, we suggest, in the displacement of a secret. The enigmatic signifier Laplanche describes refers us to an unconscious sexual secret, to those words, looks, objects, and scenes with which the child, unable to interpret them, created an unconscious. The mystery that shattered us into sexuality is by definition unfathomable; in its original form, it can never be dredged up from the unconscious and worked through (like, say, the Oedipal conflict, which is a secondary repression, less profound than the uninterpretable primary repressed material). The enigmatic signifier that is the stuff of primary repression is inherently unknowable. What Caravaggio proposes in the painting we are now looking at is a restaging of a scene of erotic provocation in which excitement would no longer be a function of an impenetrable subjectivity. The possibility of reading the youth's smile as a provocative sign of that subjectivity is forestalled by the multiple fanlike structures in the painting, structures that open out into a purely external space. Several versions of this fanlike movement create an interior framing circle: the red drapery, the ram's horns, the boy's legs, and the leaves of the plant in the bottom right corner (frequently a charged site in Caravaggio's work). The scene thus opens out, centrifugally, in various directions, countering the centripetal pull of the youth's gaze. Only his right arm traces a single direction, but its gesture is extended by the tree in the upper right corner and ends somewhere outside the painting's frame, thereby making its destination somewhat indeterminate. Nudity here signifies very differently from the sense it projects in *Victorious Cupid*. There the frontal pose, the well-lighted genitals, the centered pelvis, and the suggestive glimpse of Cupid's buttocks all encourage us to sexualize the gaze; the sexual nature of the message is confirmed by the prominence of the emblems of sexuality. In *St. John the Baptist with a Ram*, the sexual nature of the enigmatic gaze is problematized by the comparative insignificance, pictorially speaking, of those same emblems. The only dead part of the painting is the youth's genitals and the shaded area of his body just above his genitals. Even the boy's spread legs have to be read less as an erotic provocation than as merely one in a series of fanlike structures opening outward, away from the youth's body. Three of these structures could also be read on a single vertical line, from the

plant to the legs to the horns, a movement in which the most explicitly sexual element of the picture becomes a minor episode on the way.

And yet the provocative address, with the suggestion of a secret (what do the youth's smile and gaze mean or intend?), has by no means disappeared. The persistence of the enigma, and the shift in its sense, are both nicely figured in the ram's horns. Inwardly, they confine space and point to the youth's face, thus confirming his gaze and smile as the painting's narrative center. But in their outward spread, the horns de-narrativize the picture, extending the youth away from himself, connecting him, as the other fanlike structures do, to a realm of being he can't contain, where there are no borders or figures, no beginning or end. This, then, is the youth's secret, one not of interiority but rather of indefinite extensibility, a secret of unrepresented, and unrepresentable, ontological affinities. The fact that the smile, the look, and the pose that designate that secret continue to be identifiable as erotically provocative does, however, suggest that this sublimation of the erotic signifier may be an eroticized reexperiencing of it. In psychoanalytic terms, the renewed research into the trauma of an enigmatic sexuality dissipates the hidden sexual content of the trauma while reasserting its sexual energy. Painting makes visible the sensual grounds of a metaphysical fantasy.

That move is, however, made at a certain expense. If, as we have been arguing, this painting suggests that Caravaggio's youth, for all his centered presence and insistent gaze, is not to be found—or more exactly contained—within this painting, then perhaps his look might be read as a call, an appeal. It is not the peremptory call of Jesus, summoning Matthew to follow him on his pastoral mission in the world. No: the youth's arm is pointed away from us, toward those spaces where he is already, and his head could perhaps be read as an appeal from behind his arm, from a region he can no longer leave. Join me, although where I am is somewhere between two realms of being, between my physical, individuated existence and my being as a disseminated connectedness throughout the universe—a between-ness concretely figured in the painting by a casual, poignant and haunting intimacy between two species. The transfer of being represented here exacts a price, one obliquely referred to by the anomalous creases

under the youth's eyes—as if the transfer of ontological register had *taken time*. Since the empirical individual does not age into the ontological, the time evolved must be the time of the artist's own work—more specifically, the time he needed to rework the erotic enigmas he addressed to himself, to resituate their traumatic effect from an individual unconscious to the spaces at once discovered and reinvented in painting. The concealment deployed in time is both an effect of working time and, perhaps, the imaginary time it would take to follow the trajectory of spatial being. The creases under the eyes of Caravaggio's youth are the anticipatory effect of the time it would take him to rejoin his metaphysical being, a journey to which he must sacrifice his youth and, perhaps, his very life.

Losing It

It is, however, not the youth with a ram but the painter himself whom, quite appropriately, Caravaggio represents as having made that ultimate sacrifice. In drawing his own features on the decapitated head of Goliath, Caravaggio could be thought of as saying to us: In this painting I offer you my head. Or perhaps: In painting (not just in this painting) I lose my head. Painting, he might claim, is the decapitation of the artist. It is part of the great originality of *David with the Head of Goliath* (1609–10; fig. 9.1) that Caravaggio enriches rather than reduces the sense of his work by encouraging us, pictorially, to equate this decapitation with castration. The point of David's sword is invisible; it crosses and disappears into David's genital area. What we see of the sword parallels David's outstretched arm, at the end of which we do see something: Goliath's bloody head. So the gesture of the sword is repeated above, as if the unseen violence on the phallus (from which David appears to be withdrawing his sword, as he withdrew it from Goliath's neck) could, as it were, become presentable when it is repeated as decapitation. This, of course, suggests that Goliath's head is David's phallus or, to extrapolate on this, that Goliath's head is the version of himself that David sacrifices in his self-mutilation. In addition to the implied parallelism between David's phallus and Goliath's head, other similarities encourage us to think of the two figures as one. The white drapery on David's torso falls like a head of hair, and

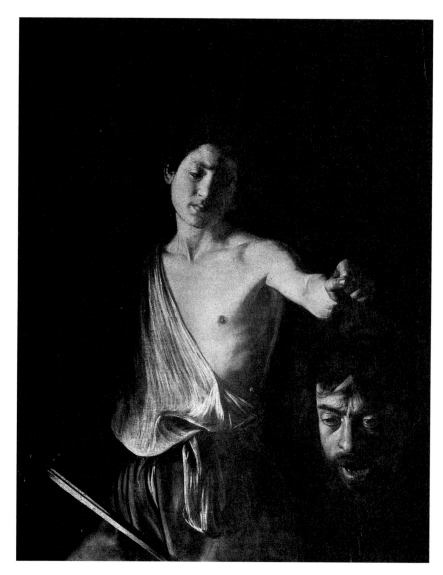

9.1 *David with the Head of Goliath,* 1609–10. Rome, Galleria Borghese. (Also plate 8.)

the hanging lower part has a shape somewhat similar to the lines of blood flowing from Goliath's invisible neck, lines to which the flowing drapery is also parallel. Note also David's red right ear, a curious repetition in the upper left section of the color of the blood in the lower right section. Finally, it is as if this act of violence had made David somewhat androgynous: there is the Madonna-like melancholy with which he contemplates the severed head, and the curiously expansive volume of the lower part of his body, as if an ample skirt had been thrown around David's hips.[1]

Castration/decapitation has left David in a state of between-ness, not only between gendered identities but also between existential violence and what Caravaggio appears to conceive of as the aesthetic consequence of that violence. David the castrator-decapitator holds his arm forth as a painter might in front of his canvas. In Goliath's head, David-Caravaggio has painted his own castration. That is, Caravaggio has symbolized it through his own severed head, thereby making visible, for us, his interpretation of a fantasy of castration. For if decapitation "hides" a castration fantasy, the latter is not a final term: only decapitation gives us the full sense, and even more importantly the profound but ambiguous appeal, of castration. Only Caravaggio's head tells us, exactly, what he has lost in sacrificing the phallus. Decapitation is the meaning of castration, for sexuality is originally implanted in the head; the phallus does the bidding of fantasy, sexuality is a *cosa mentale*. In Caravaggio's work, the head, as we have seen, is the principal carrier of erotic messages. Here, however, is a head being offered to us much less ambiguously than the head of the *bacchino malato* or that of St. John with a ram, but it is also a head that can no longer address us. This is a head without secrets, and therefore without a message; decapitation is Caravaggio's extreme solution to the human head as a traumatically enigmatic signifier.

Nothing is concealed behind those dead eyes, eyes that can no longer provoke us erotically. Or perhaps there is a message in Caravaggio's severed head, but it can only be one about interpretation. In cutting off his head Caravaggio forestalls a reading of his work which, however, he also invites in many of his paintings. The thrusting of his head toward the viewer is, to use Frank Stella's expression for this image, an extraordinary act of "pictorial will."[2] It violently

removes us from the interpretive level at which concealment has to be thought of as nonspatial (that is, when it is a function of a constitutively inaccessible and unrepresentable unconscious). In so doing, the severed head makes the very identification between decapitation and castration interpretively irrelevant. For Caravaggio, the discovery of what we have called a disseminated spatial concealment, an extension of being also unrepresentable yet nonetheless congenial to the spatiality of painting, seems to require an amputation not only of the sexual but also of life itself. Whereas the *Fortune Teller* and *St. John the Baptist with a Ram* suggest that the ontological can be sensually charged, *David with the Head of Goliath* theorizes, so to speak, the impossibility of that conjunction. This extraordinary and extraordinarily self-destructive work posits the incompatibility of existence and being. Caravaggio dies a terrible death as a victim of his metamorphosis into art.

We confess, however, to being unable to settle on any one response to *David with the Head of Goliath*. The painting authorizes quite different readings from the one we have been proposing. Near the end of our interpretive itinerary, we want to risk setting our own heads afloat in an uncertain and obscure space not unlike that uninhabited darkness from which Goliath's head is thrust toward us. The severed head should perhaps be read, not as an emblem of the painter's violent removal from the source of the erotic secret, but rather as the loss of a physicality unconstrained by the circuits of contact initiated by the enigmatic address. The painting is, after all, a representation of bodily mutilation and absence. Not only is the rest of Goliath's body missing; David's right arm nearly disappears into the painting's broad dark background. (Was this arm originally visible? The painting, we should note, is in poor condition.) Goliath's decapitation would not be the (fantasmatic) precondition of the spatiality designated by the centrifugal sensuality of *St. John the Baptist with a Ram*; instead, it would aggressively remind us of the separation of the sexual from the sensual, of our now being condemned to a space in which there remains *only* the head. Once the head is substituted for the genitals, the hegemony of the sexual is, paradoxically, assured. A part of the body has become an organ of consciousness; it is now on top, subordinating an otherwise unstructurable sensuality to its insistent if

unintelligible message. Now all the objects of desire are hidden; or, more exactly, the sexual is constituted by the hiding of those objects, thereby initiating and perpetuating the regime of desire as lack.

David with the Head of Goliath could, then, be thought of as representing both a violent disqualifying of the enigmatic signifier and the fantasmatic act by which it is instituted. The very tension between these two possibilities may account for yet another reading that the painting proposes to us. If by cutting off his head Caravaggio can't help but grimly celebrate its presence, making it more than ever the object of our fascinated look, then the only hope of detaching our (and David-Caravaggio's) gaze from this head (that manages still to solicit us even when it can no longer be hiding anything from us) may be to paint its withdrawal into a field of nearly undifferentiated darkness.[3] Bellori, in his description of Caravaggio's "novelty" and of the "facile manner [that] attracted many," wrote that Caravaggio "never brought his figures out into the daylight, but placed them in the dark brown atmosphere of a closed room, using a high light that descended vertically over the principal parts of the bodies."[4] (This is, incidentally, practically a description of the setting of the *Calling of St. Matthew*.) There are dangers and opportunities in this setting, and both are represented in Caravaggio's work. He physically witnesses his painting not only in the sense discussed earlier of a bodily projection onto his subjects; he also makes visible the very conditions of his working space. *David with the Head of Goliath* suggests why the painter might be seduced by the prospect of seeing nothing in the darkness of his closed room. His sense of being engulfed by the very setting in which he has chosen to work resolves, albeit in nihilistic fashion, the dilemma of a head whose prominence and power may be only increased by its separation from the body. But there are other possibilities. The enveloping darkness is an escape only from vision, and this liberates a sensuality otherwise preempted by the exciting but stultifying secrets of the enigmatic gaze. The absence of distinct visible elements in space makes palpable the physicality of space. Unable to measure distances, the painter rediscovers space as a tactile, unmappable extension of his body. Thus, the darkness of Caravaggio's work provides an atmosphere in which the violent solution of decapitation itself may disappear. The body's unmeasurable connectedness,

———

its unmappable extensibility into space, can then be realized not through the mutilation of the enigmatic signifier, but rather through a kind of sensory reorganization, a subordination, most notably, of the visible to the tactile.[5]

Finally, the darkness into which David pushes Goliath's head could be thought of as the environment of another kind of extensibility, the spatio-temporal extensibility of spectatorship. Stella speaks of Goliath's head passing by us "as an exploded point about to disperse itself into a continuum of movable pictorial space, going beyond us to create the space of our pictorial present and future." Devoid of narrative elements, Caravaggio's ambient darkness is the painter's provision, at once generous and self-confident, for all the glances that, from inside and outside painting, in his present and in the future, will meet at his severed head. This fruitful collision might even propel the head out of its morbid fixity. Stella proposes that "the head of Goliath can be sent spinning by the force implied in the multiple, moving visions caught by the glances within and outside of the painting—glances from the eyes of David, Goliath, and Caravaggio perpetually reactivated in the eyes of successive viewers, glances whose energy turns the perfectly poised head of Goliath suspended from David's hand the way air currents almost automatically turn a Calder mobile suspended from its fixed point." Decapitation is perhaps the precondition of that energy. Caravaggio's head, no longer the fixed object of our fascinated gaze, is there *to be moved, to be spun.* The painting no longer has to be read as the ultimate expression of what Stella calls Caravaggio's "hysterical psyche."[6] The removal of Caravaggio's head from his body disorients our reading of the painter's "head," of his meaning. It is, now, the happy solution to the excessive coherence of a unified body, a unified being. The very deadness of Goliath-Caravaggio's head makes of it not the object that arrests spatial trajectories, but rather merely a point along trajectories not yet made. It initiates new spatial crossings, thereby bringing into a painting's frame the space outside the painting to which the young man's gaze in the *Fortune Teller* directs us, and toward which the fanlike structures of the Capitoline *St. John the Baptist* reach.

There is, then, no certain answer to the question of how we should view decapitation. If cutting off the head illuminates the sense of castration, the sig-

nificance of decapitation is not at all clear. Far from foreclosing all interpretation, Goliath's severed head, surprisingly, sets interpretation itself afloat. In *Judith and Holofernes*, as well as in the London *Salome Receiving the Head of St. John the Baptist*, different ways of looking at decapitation are represented within the painting. These works bring us back to the importance of the witness in Caravaggio's work, but now we discover a kind of witnessing dramatically different from the self-projective activity by which the witness in the *Betrayal of Christ* entered that subject in order to experience it as a mode of relationality. Caravaggio as witness entered the historical in order to prevent us from reading the work *as* history. Nothing could be more different from the static intensity of the old woman in *Judith and Holofernes* (c. 1599; fig. 9.2). She brings, first of all, linear time into the scene. The beheading itself has the temporal ambiguity—or rather the atemporality—noted earlier in our discussion of the *Betrayal of Christ*. The sword appears to be just beginning to slice into Holofernes' head, although the lines of blood suggest that it is further advanced. A curiously nonrealistic representation (the lines resemble long thin red ribbons rather than flowing blood) freezes the act of violence, substitutes for the movement of violence a highly visible acknowledgment that the scene has been set up, with something else "posing" as blood. While this may mean that the painting's subject should be read as the occasion for representing something else, the old woman partially blocks any such metamorphosis. She narrativizes the scene, making it historically literal, as she waits for the head to be severed so that she can carry it away in the cloth already prepared to receive it. She looks intently, and waits.[7]

Interestingly, Caravaggio associates this kind of frozen witnessing, as he does the witnessing of the *Betrayal of Christ*, with the aesthetic. It designates both a mode of spectatorship and a mode of production. Here the aesthetic emerges from a secure distinction between subject and object. Because of this, the witnessing typified by the old woman corresponds to an art that "respects" the historical subject. Art is not what happens when the witness/viewer represents his or her felt connectedness to the subject's physicality. Instead, the work's subject is now presented as an immobilized and framed spectacle, cut off from the moving spatial relations that would make it unidentifiable as a subject. In the

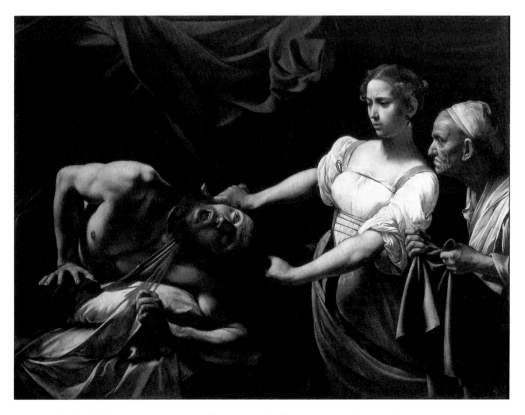

9.2 *Judith and Holofernes,* c. 1599. Rome, Galleria Nazionale d'Arte Antica, Palazzo Barberini.

Martyrdom of St. Matthew (c. 1599–1600), a petrified and petrifying spectatorship enters, very curiously, as a mode of connoisseurship in the very midst of the frenzied action. At the lower right of the painting, two figures seem rather comfortably installed as a curious and disinterested audience of the massacre of St. Matthew. One of them appears to be staring at the saint's head; the other, resting his face on his left hand, is probably looking up at the executioner. (Caravaggio also painted his own features on the bearded man in the left background who appears to be leaving the scene even as he turns pensively toward it.) These two figures—like the old woman in the *Judith* work, but more deliberately evocative of the "artist" than she is—embody what we spoke of in our study of Assyrian sculpture as a mimetic fascination with violence. Their intense concentration on the work's narrative center suggests an attempt to isolate the scene of violence in order to "get it right," to "know" it. And the getting right, we speculated in the *The Forms of Violence*, can only be an imitation of violence, one sustained by the masochistic excitement accompanying the imaginary replication.[8] (As Alberti says of successfully mimetic art, it stimulates the desire to participate in the represented action.) An apparently dispassionate wish to understand or to know violence is "satisfied" by being defeated; the excitement of participation brutally desublimates the pursuit of knowledge.

An art that appeals to a mimetic fascination with the violence it represents frequently denies that appeal by monumentalizing the scene of violence. The representation of violence is frozen, and the scene is enjoyed, visually, at a distance, purified of the disorder that was its promise, the source of its appeal. In *Judith and Holofernes*, this movement away from existential immediacy is in part manifested by the nonhuman, leathery quality of the old woman's skin, in part by the statuesque pose of Judith herself. Her arms (somewhat inappropriately, given what she's doing) have a sculptural immobility, and her projecting breasts are like a shield or plate of armor. And yet there is something ambiguous about Judith's role in this scene. She reaches toward Holofernes to accomplish the beheading, at the same time that she appears to be retreating from this act. She moves away from the violence both in her puzzled or repulsed expression and in her upper body's slight movement backward (in contrast to the unhesitant

movement forward of the old woman's head toward the prize she will soon be carrying away). Judith stands between the old woman and Holofernes not just physically but also in the way she views decapitation. This suggests, somewhat bizarrely, that Holofernes has a view of (or, even more strangely, a point of view on) his own decapitation, and yet that is exactly what Caravaggio paints at the center of his work. Holofernes' open eyes move us away from the act of which he is the helpless victim. Narratively helpless, to be sure, but also mounting, at the very moment of death, a powerful resistance to the fixed horizontality of the old woman's gaze. Narrative violence releases an uncontrollable energy: Holofernes seizes decapitation as an opportunity to whirl away from the scene of violence. And *we* can't look at him in the way the old woman (and, more reluctantly, Judith) look at him because what we see, directly in front of us, are eyes looking upward, with a head that may be on the point of following its own look out of the picture. Holofernes' eyes are directing us to spaces outside the scene in which he is on the point of no longer being able to see anything.

Narrative or historical violence is not defeated merely by its witnesses turning away from the spatial frames in which it takes place. It is, however, also true that this defeat can never take place if the human fascination with the spectacle of violence is not, as it were, deprogrammed. The visual arts—and we refer not only to the "high art" of Caravaggio—can play an important role in the project of retraining the human look. It could probably never be a question of eliminating the obscene fixation with the mechanics of violence embodied by the old woman in the *Judith* painting, inasmuch as that fixation is, we believe, grounded in the excited but anguished interrogation of an originary enigmatic and invasive soliciting of our very being. If being human depends to a significant degree on that soliciting, then the paranoid aggression that is its consequence cannot be wholly erased. Decapitation can hardly be offered as a model of how to live *with* our heads. It may, as we have said, be Caravaggio's extreme, and unviable solution to the trauma provoked by the enigmatic signifier. It should, however, be noted that Holofernes' eyes are considerably more active than those of Goliath. If the locus of the erotic secret is being subjected, in *Judith and Holofernes*, to the same fate as it is in *David with the Head of Goliath*, the head itself in the

former work is instituting relations it would normally be thought of—luridly privileged as the image of the head is—as not allowing the viewer to entertain. Here the head, the object of violence, moves us away from itself, which suggests that there might be ways to think of narrative subjects of violence as including cues for their own dismissal. Or at the very least, for a displacement of our visual and ethical interest not only from scenes of historical violence, but also from their probable source in our paranoid attachment to that other—those others—who originally called us to them but whom we could never reach.

Because the movement away from decapitation is, in *Judith and Holofernes*, an effect of decapitation itself, the painting vindicates the very narrativity it also manages to escape. The destabilizing of a narrative mode of spectatorship is a consequence of the narrative context; the latter makes visible the tension between it and other forms of connectedness. The London *Salome* (1607; fig. 9.3) suggests that this escape should be reformulated as an accommodation. Salome is holding the platter on which the executioner is placing the head of St. John, but she seems curiously uninterested in the scene.[9] Her face is far less expressive than Judith's; she is simply looking away, toward a space somewhere outside the painting. And yet, while Holofernes' eyes suggest that he might literally fly off from the space of his beheading, *Salome*'s composition keeps its principal female figure firmly within the painting. She is part of a complex structure of couplings. The old woman's head, like the dead saint's, is pointed downward; her stonelike face makes her the least alive of these living figures and, nearly hidden from view, she is, like her "partner," little more than a head within the painting. Salome and the executioner are compositionally parallel: both are turned toward our left, her right hand and his left hand frame the work's lower section. He, however, is also paired with the head he is holding and looking at, while Salome and the old woman create one of those twinning effects we have seen elsewhere in Caravaggio's work (is the woman's head a "growth" on Salome's body?).

The old woman is, once again, the figure for an absorption in violence, for an unidirectional gaze grounded in a paranoid fascination with the enigmatic signifier. That fascination, we have been arguing, is the originary mode for a relationality in which subject and object are separated by the distance of an imag-

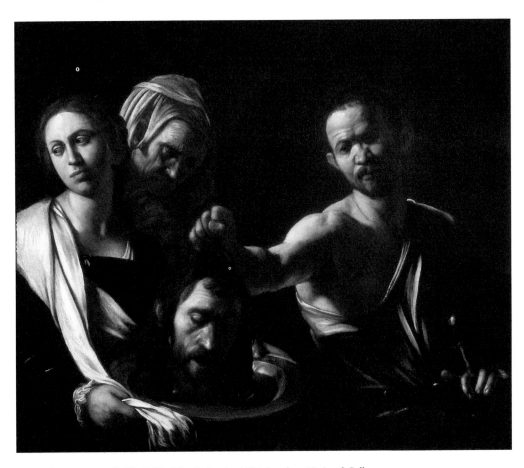

9.3 *Salome Receiving the Head of St. John the Baptist,* 1607. London, National Gallery.

inary secret, a distance that only "knowledge" might cross or eliminate. The pairing of the old woman with St. John's head nonetheless reminds us that they both belong to the same system, that the very constitution of this subject-object relation depends on a single fantasy of the other soliciting us with an unreadable address. This is the archaic origin of violence toward the other's impenetrable difference. In Caravaggio's work, decapitation is represented as the equally archaic solution to the subject's assault by incomprehensible messages from a hopelessly remote if intimate partner. He will remove the head that is the source of those messages. The pairing of Salome with the old woman, which might appear to be a yoking together of opposites, also suggests the impossibility of a total break with this primitive scene and this primitive relation. Just as the youth's somewhat enigmatic look in *St. John the Baptist with a Ram* might be read as an ironic commentary on the optimistic message of that painting's fanlike structure (a centripetal movement counters a deceptively limitless spatial extensibility), so Salome is incomplete without her archaic twin. Each has the flatness of a desire that fails to acknowledge the other; only their forced conjunction dynamizes the space they inhabit.

The necessity of that conjunction is perhaps most forcefully confirmed by the importance given to the executioner, who occupies half the space of the painting. If this enriches the work structurally (the executioner's prominence adds to the pairings just noted an asymmetrical division between the right half of the canvas and the three crowded figures to the left), we may also find it semantically anomalous. Salome, the work's subject, seems almost like a reluctant presence in the painting, which is spatially dominated by a figure who is merely an accessory to the work's significance. His coupling with Salome, however, points to a far more important function. His look, like hers, could be read as affectively neutral, as somewhat indifferent to the violence of which he is both the agent and the principal witness. He is very much in the scene and yet somewhat removed from it. If by his look, parallel to Salome's, Caravaggio suggests that he is far from riveted to the scene of violence, that he too might be ready to turn toward other spaces, there is no indication that he shares Salome's illusion: that it is possible to leave, or even to ignore, *this* space. *There is only one*

space, and it has to include the event that impoverishes our experience of space. The relationality derived from an anguished interrogation of the head, and its presumed secrets, is after all itself a self-extension, one way (indeed, a founding if restrictive way) of reaching out to the world. It is a way of cutting into space, of shaping it.

Cutting into and shaping space: was Caravaggio interested in executioners as a mode of self-representation?[10] The executioner's gesture in *Salome*, like David's, is not unlike that of the painter reaching out toward his canvas. The notion of the painter as a witness within his work, and, correlatively, of the work as the form of the painter's active looking at his subject, must now be further specified to accommodate a certain violence perhaps inherent in that looking. The painter cuts into his subject, nearly destroys it, in order to reshape it as the mode of relationality he discovers by physically entering his subject.[11] And it is by a visual concentration on the forms he is producing that he learns how his body, through his outstretched arm, is violating his subject by the physicality of his implication in it. Only Caravaggio's identification with his executioners can, it seems to us, explain his repeated emphasis on the executioners' looking at the evidence of their violence. David, the Hun in the *Martyrdom of St. Ursula* (1610), the executioner in *Salome*, even Judith whose look competes with Holofernes' eyes as a center of dramatic interest: in all these cases, the executioners' looking at their work may have been the principal object of the painter's interest as he looked at *his* work. The represented looks solicited by the severed heads and helpless victims are, however, somewhat detached. The head no longer has the power to fascinate the subject—here, the painter/executioner—with the secret of his own alienated being. By his detachment, the executioner in *Salome* signals his availability to other interests and to the other spaces toward which Salome looks, and which he is at least positioned to begin taking in. But he also insists, by his prominent visibility, on the impossibility of our ever detaching ourselves entirely from both imaginary and real scenes and sources of violence. We can never be entirely freed from our fascination with lack, with what is missing from our being and what we imagine as hidden in the other's head.

There is no getting rid of the head, and that is perhaps what David, thrusting Goliath's head toward the viewer, is meant to remind us of. Anecdotally, David, like Judith and the executioners in the *Salome* paintings, has removed (or is in the process of removing) a head, but for the viewer that very fact emphasizes the head's presence. The itinerary from the erotically provocative *bacchino malato* to these images of decapitation has led us far from a fascination with the enigmatically soliciting look. It has led us, principally, to other modes of spatial (and, implicitly, of affective and moral) connectedness. But at the end of this itinerary the scenes of decapitation themselves include a message about the impossibility of decapitation. Not only does decapitation/castration fail to relieve the anguish provoked by an enigmatic signifier; as Holofernes' about-to-be-spinning head suggests, every deconnecting will also immediately become a reconnecting. The experience of the enigmatic signifier—an experience that reduces our being to a doomed resolution to master difference—can itself find a place on a map of relationality no longer impoverished by that resolution. *Everything* connects to and within the wholeness of being. In our first reading of *David with the Head of Goliath*, we said that Caravaggio dies a terrible death as a result of his metamorphosis into art. But now we see the possibility of an aesthetic that may owe nothing at all to sacrifice, that may be identical to a total acceptance and even, in painting, to an implicit sanctification of all space. Much of Caravaggio's work raises the question of whether Goliath's death was necessary—a question almost unspeakably poignant if we see in David's expression a melancholy attachment to what he has *de*tached, a belated recognition that there are life-sustaining and even self-expansive modes of losing your head.

NOTES

1 SEXY SECRETS

1

We will be following the dating of Caravaggio's paintings proposed by one of the leading Caravaggio scholars, Mina Gregori, in her 1994 *Caravaggio* (Milan: Electa). These dates are provided in order to give the reader a general chronological orientation; we will not be entering into the frequently lively dating controversies in Caravaggio scholarship.

The Bacchus self-portrait was first designated as the *Bacchino Malato* by Roberto Longhi in 1927.

2

Jacques Lacan, *The Four Fundamental Concepts of Psycho-Analysis*, ed. Jacques-Alain Miller, trans. Alan Sheridan (New York: W. W. Norton, 1978), 96 and 86.

3

We observe in addition the distancing effect of Cupid's slightly mocking, self-controlled smile—in sharp contrast to the immodest full frontal spread of his naked body—as well as the absence of part of that otherwise fully exhibited body, especially the left arm hidden behind the curiously contorted pose. Cupid's legs and his hidden left arm recall Michelangelo's *Victory*, where, obviously, similar positions of the limbs don't serve a representation of erotic provocation and concealment. Creighton E. Gilbert has, however, pointed out that in interpreting other images of male figures reaching behind with one arm from the same period, "dignified

scholars have said they are grasping a buttock to break wind or defecate." *Caravaggio and His Two Cardinals* (University Park: Pennsylvania State University Press, 1995), 235.

4

For the painter alone, however, that performance can have an exceptional visibility. By painting his own features on the face of the *bacchino malato,* Caravaggio can experience the *bacchino*'s partial withdrawal of the address as being performed by the excluded spectator (that is, Caravaggio), at the same time as he can witness his own *jouissance* as the seducer, the *jouissance* not of penetrating his secrets but of seducing the other with and through them. Thus, only through these narcissistic refinements of art can the conditions of erotic soliciting be at least partly controlled.

5

Donald Posner, "Caravaggio's Homo-Erotic Early Works," *Art Quarterly* 34 (1971): 302, 304–07. In more summary fashion, Michael Kitson had already referred to the youths in the early paintings as "erotically appealing boys painted by an artist of homosexual inclination for patrons of similar taste." *Victorious Cupid,* Kitson claimed, "is blatantly designed with this in view." *The Complete Paintings of Caravaggio* (New York: Henry N. Abrams, 1967), 7.

6

Howard Hibbard, *Caravaggio* (New York: Harper and Row, 1983), 87 and 159. For S. J. Freedberg, *St. John the Baptist with a Ram* "is not just anti-ideal; it is a derisive irony, and in a sense a blasphemy, which intends an effect of sacrilege and shock. . . . The measure of Caravaggio's aggression against Michelangelo is in proportion to the latter's towering ideality, but there may be a less theoretical basis for it—a reaction to Michelangelo's veiling and sublimation of a sexual disposition that Caravaggio in his art had made explicit." Freedberg, *Circa 1600: A Revolution of Style in Italian Painting* (Cambridge, Mass.: Harvard University Press, 1983), 59.

7

Gilbert, *Caravaggio and His Two Cardinals,* 192–99, 213, 242, 245, and 249. For Posner, the *bardassa* testimony is crucial to his confident assertions about Caravaggio's homosexuality.

8

For an excellent discussion of representations of homosexuality in art, as well as of social attitudes toward homosexuality, during the period that interests us, see James Saslow, *Ganymede in the Renaissance: Homosexuality in Art and Society* (New Haven: Yale University Press, 1986).

9

Saslow points out that androgyny could, as in the case of Leonardo, serve to represent an escape from any kind of sexuality. See *Ganymede in the Renaissance,* 85.

10

Marcel Proust, *Cities of the Plain* (English title for *Sodome et Gomorrhe*), in *Remembrance of Things Past*, trans. C. K. Scott Moncrieff and Terence Kilmartin, 3 vols. (New York: Vintage, 1982), 2:643–44.

11

Posner, "Caravaggio's Homo-Erotic Early Works," 303.

12

Proust, *Remembrance of Things Past*, 2:637.

2 WHERE TO LOOK?

1

Caravaggio scholars (most notably, Denis Mahon and J. -P. Cuzin) have questioned the attribution of the Capitoline *Fortune Teller* to Caravaggio. In 1951 Mahon wrote that the composition of the Capitoline painting "is in every detail more flaccid than the Louvre version, . . . [it] is 'Caravaggio made easy,' without the peculiar accent, without the spice." Given this reaction to the picture, it is hardly surprising that Mahon concluded that it was the work of "a superficially clever and relatively early imitator." See Mahon, "Egregius in Urbe Pictor: Caravaggio Revised," *Burlington Magazine* 93, no. 580 (July 1951): 234.

On the basis of a radiographic examination of the Capitoline *Fortune Teller*, Michele Cordaro reattributed it to Caravaggio. See Cordaro "Indagine radiografica sulla 'Buona Ventura' dei Musei Capitolini," in *Ricerche di Storia dell'Arte* 10 (1980): 101–06. For a brief history of the debate around the Capitoline version and an account of this painting's cleaning and restoration in the mid 1980s, see Maria Elisa Tittoni Monti, "*La Buona Ventura* del Caravaggio: note e precisazioni in margine al restauro," and Elena Zicieri and Claudio Caneva, "Relazione tecnica di restauro e analisi," *Caravaggio: nuove riflessioni*, in *Quaderni di Palazzo Venezia* 6 (1989): 179–97.

2

Mina Gregori, in the catalogue for the exhibition *The Age of Caravaggio* (New York: The Metropolitan Museum of Art; Milan: Electa, 1985), 215 and 220; Alfred Moir, *Caravaggio* (New York: Harry N. Abrams, 1982), 52; Giulio Mancini, *Considerazioni sulla pittura*, ed. A. Marucchi, 2 vols. (Rome: Accademia Nazionale dei Lincei, 1956–57), 1:109. In her catalogue essay, Gregori argues for a relation between the *Fortune Teller* and certain features of the *commedia dell'arte*, and, more generally, "a tradition of theater-related genre painting." *The Age of Caravaggio*, 215–16.

3

See Maurice Merleau-Ponty, *The Visible and the Invisible*, ed. Claude Lefort, trans. Alphonso Lingis (Evanston: Northwestern University Press, 1968), especially chapter 4, "The Intertwining—The Chasm."

4

It should, however, be mentioned that the youth's advantage is social as well as ontological; indeed, one could maintain that the social is posing as the ontological. We would, however, argue that the type of visibility the youth proposes is the first step in a democratizing of their relation, in what might be called a spatially motivated democratizing. We will come back to the relation between class and representation in Caravaggio in our discussion of his portrait of Alof de Wignacourt, as well as in our consideration of the prominence of his models *as* models in the religious paintings for which they most frequently pose.

5

The gesture does, of course, as others have pointed out, also evoke Adam's inert outstretched hand in Michelangelo's *Creation*.

6

Caravaggio has often been criticized for a weakness in defining depth. As an example that "confirm[s] the opinions of the old writers that Caravaggio was poor at diminution and perspective effects," Hibbard refers to "errors" in the earlier London version of the *Supper at Emmaus* (1601): the innkeeper's "unusually large" hands, and the fact that "the extended hands of the disciple at the right are of about the same size, even though one is thrust toward us and the other . . . is as far from us as possible." Hibbard, *Caravaggio*, 78.

7

Specifically, Marin studies the way in which "a certain perceptual depth emerges" in Poussin's *Israelites Gathering Manna in the Desert*, a depth allowing us to grasp the work's "pure syntax," the temporal order it spatially represents. Louis Marin, *To Destroy Painting*, trans. Mette Hjort (Chicago: University of Chicago Press, 1995), 77–78.

8

With the immense complication of the very notion of the visual in contemporary technological culture, the nature of looking has become especially problematic. But while the problem has been exacerbated by such developments as the independence of images from material supports, the disoriented look is the consequence of a disruption of security evident long before the new conditions of visuality created by modern technology. On these new conditions, see the issue of *October* devoted principally to "visual culture" (no. 77 [Summer 1996]).

3 MORTAL MEDITATIONS

1

Walter Friedlaender emphasizes the importance for Caravaggio of "the informal atmosphere of the spiritual life created in the second half of the sixteenth century by Filippo Neri" ("Rome's most popular saint"). "From the pietistic movements of earlier times [the Filippini] had inherited a simplicity of faith and a mystic devotion which gave each individual a direct and earthly contact with God and His Mysteries." *Caravaggio Studies* (Princeton: Princeton University Press, 1995), 122–23.

In contrast to modern psychological readings of Caravaggio's paintings, Maurizio Calvesi has attempted to reinstate Christianity as the interpretive key to the painter's work. For Calvesi, even the early works should be read in terms of such Christian themes as salvation and redemption. In his representation of Bacchus, for example, Caravaggio is seen as including elements that encourage us to identify Bacchus as prefiguring Christ. See Calvesi, *La realtà del Caravaggio* (Turin: Giulio Einaudi, 1990).

2

Not only is Matthew's gesture centrally placed, but our attention is also drawn to that space by the lines pointing toward it. If we were to extend two diagonal lines going in opposite directions—the upper border of the shadow on the wall behind Christ and Peter, and the sword of the seated figure in the foreground—they would converge just above Matthew's hand.

3

Hibbard, *Caravaggio*, 243.

4

The composition of the *Resurrection of Lazarus*, as Richard E. Spear has shown, is not without antecedents in the Italian tradition (specifically, in works by the Cavaliere d'Arpino and Federigo Zuccaro). Spear, "The 'Raising of Lazarus': Caravaggio and the Sixteenth Century Tradition," *Gazette des Beaux-Arts* 65 (February 1965): 65–70.

In an interesting essay, Giulio Carlo Argan has written that Caravaggio paints reality from the perspective of death rather than of life. As a result, his work is "unnatural, anti-historical, anti-classical, and is, instead, profoundly and desperately religious." Argan, "Il 'realismo' nella poetica del Caravaggio," in *Scritti di storia dell'arte in onore di Lionello Venturi*, vol. 2 (Rome: DeLuca, 1956), 36–37.

5

All three of these accounts were written several years after the events. They are symptomatic of a certain sensitivity (by no means universal) in Caravaggio's own time and later in the seven-

teenth century to elements in his work that violated the "proper" or "decorous" manner of representing sacred scenes. In her recent book-length study, Pamela Askew argues that Caravaggio's painting was rejected because it failed to conform to the mariological ideals of the reformed Discalced community in Rome by presenting the Virgin as a "haloed commoner. It is not the fact that she is shown dead, or that she lacks physical propriety, but that the physical and pictorial majesty with which Caravaggio has endowed her is not specifically referred to her royal suzerainty. Although her lowliness could be equated with the virtues of humility and poverty, this would not have been sanctioned at the expense of compromising her queenly station." Askew, *Caravaggio's "Death of the Virgin"* (Princeton: Princeton University Press, 1990), 63. Chapter 4, "Rejection," reviews the history of the painting's rejection, quoting from the seventeenth-century sources referred to in our text.

Maurizio Marini identifies the bronze bowl in the foreground, containing vinegar to wash the corpse, as Caravaggio's brutal if unconscious confession of his lack of faith in the Resurrection and in the Assumption. Marini, *Michelangelo Merisi da Caravaggio "pictor praestantissimus"* (Rome: Newton Compton, 1987).

6

Hibbard, *Caravaggio*, 202.

7

Very different interpretations of the curtain have been proposed by Askew and Calvesi. The latter associates the curtain's redness with divine triumph and resurrection. Maurizio Calvesi, "Caravaggio o la ricerca della salvazione," *Storia dell'Arte* 9–10 (1971): 133. For Askew, the curtain also emphasizes the link between the Virgin and Christ: "Caravaggio's curtain, formally echoing the curves and volumes of the Virgin's form, is the sign of the material substance of which the Word made flesh was composed, a visual metonym for the consubstantiality of the Virgin and the deity. Its scale magnifies the importance of her divine maternity, just as its color, deeper than the red of the dress clothing her body, projects the idea of her womb as the vehicle of the Incarnation. Conceptually, the red curtain makes the viewer aware of the body and blood of Christ." Askew, *Caravaggio's "Death of the Virgin,"* 116. The history of uses of a curtain to fortify such associations, uses Caravaggio may have been aware of, does not, we feel, invalidate our reading of the particular correspondence between the curtain and the Virgin's body registered in this particular painting.

8

Herwarth Röttgen notes that the painting is rotated some twenty degrees from the frontal norm, like a sculpture seen in the round. *Il Caravaggio: Ricerche e interpretazioni* (Rome: Bulzoni, 1974), 94–95.

The *Entombment* was painted for the Chiesa Nuova in Rome. For Hibbard it is best understood in the context of a chapel; he sees it more as a presentation of the *corpus domini* rather than a deposition (*Caravaggio*, 174). Finally, from the vast body of commentary inspired by this work, we might mention that Friedlaender reads the emphasis on the corner of the stone as an allusion to Christ as the foundation or the cornerstone of the Church. For him, it may also refer to the stone of unction on which Christ's body was anointed (intimately associated with the Pietà rather than with the Entombment), while Leo Steinberg refutes this reading by arguing that the stone is the slab that will seal the rectangular opening of the sepulcher. In the impression it gives of being resistant to penetration, the jutting slab therefore emphasizes the wonder of the Resurrection. Friedlaender, *Caravaggio Studies*, 127–28, and 188; Steinberg, "The Sexuality of Christ in Renaissance Art and in Modern Oblivion," *October* 25 (Summer 1983): 155–56.

9

It should, however, be mentioned that Hibbard proposes a more realistic account of this light: Caravaggio has painted the way the light from the upper right window would hit the painting in the Chapel of the Chiesa Nuova, for which it was originally intended (*Caravaggio*, 172).

4 THE ENIGMATIC SIGNIFIER

1

Jean Laplanche, *Seduction, Translation, Drives*, ed. John Fletcher and Martin Stanton, trans. Martin Stanton (London: Institute of Contemporary Arts, 1992), 188. See especially the section "The Kent Seminar" and the essay by Laplanche from which the quoted passage is taken, titled "The Drive and Its Object Source: Its Fate in the Transference."

2

See chapter 1 of Leo Bersani and Ulysse Dutoit, *Arts of Impoverishment: Beckett, Rothko, Resnais* (Cambridge, Mass.: Harvard University Press, 1993).

3

Bersani and Dutoit, *Arts of Impoverishment*, 147; *The Standard Edition of the Complete Psychological Works of Sigmund Freud*, ed. James Strachey, 24 vols. (London: Hogarth Press, 1953–74), 14:133 and 139. Freud speaks, also in "Instincts and Their Vicissitudes," of a nonsexual sadism that consists in "the exercise of violence or power upon some other person as object" (14:149–50). We use the word sadism to refer to this project of mastery over the world. We address this project, as well as the problems involved in conceptualizing a nonsexual sadism, in *Arts of Impoverishment*, 147–56.

4

For Heidegger, "self-concealing being is illuminated" in art. "This shining . . . is the beautiful. *Beauty is one way in which truth occurs as unconcealedness.*" Martin Heidegger, "The Origin of the Work of Art," in *Poetry, Language, Thought,* trans. Albert Hofstadter (New York: Harper and Row, 1971), 56 (emphasis in original).

5 ARTISTS AND MODELS

1

Marin, *To Destroy Painting,* 32. Marin begins his study by quoting Poussin's famous remark, as it was reported by André Félibien in his 1725 *Entretiens sur les vies et sur les ouvrages des plus excellents peintres anciens et modernes, avec la vie des architectes:* "Poussin could not bear Caravaggio and said that he had come into the world in order to destroy painting."

2

As Walter Friedlaender has pointed out, Caravaggio's composition here is similar to that of Titian in the Prado *Allocution of General Vasto (Caravaggio Studies,* 221). However, the gaze of Titian's page (who is also looking toward the viewer) is considerably less ambiguous, and less commanding of our attention, that that of Caravaggio's squire. Hibbard, in opposition to other Caravaggio scholars (and, in this instance, most notably Gregori), does not attribute the squire to Caravaggio (*Caravaggio,* 327).

Alberti thinks it's a good idea to have "some one in the 'historia' who tells the spectators what is going on, and either beckons them with his hand to look, or with ferocious expression and forbidding glance challenges them not to come near, as if he wished their business to be secret, or points to some danger or by his gestures invites you to laugh or weep with them." Alberti, *On Painting,* trans. Cecil Grayson (London: Penguin, 1991), 77–78. Far from instituting a genuine interaction between the spectator and the work, however, such mediating figures actually protect the inviolability of the viewer's look, preserving it from any perceptual or interpretive uncertainty. Jean Louis Schefer, in a commentary on Alberti's work, speaks of the "strangely sterile" fiction according to which there is no "center of intention and consciousness other than the geometric construction that places the eye at the summit of the pyramid," thus eliminating "any possibility of interaction." Alberti, *De la peinture,* trans. Jean Louis Schefer (Paris: Macula, Dédale, 1992), 15.

6 BENEFITS OF BETRAYAL

1

Alberti, *On Painting*, 60, 64, and 76–77.

2

Ibid., 90 and 75–76.

3

Michael Baxandall persuasively elaborates the idea that Alberti's compositional model for painting was borrowed from the humanist discipline of rhetoric. Baxandall, *Giotto and the Orators: Humanist Observers of Painting in Italy and the Discovery of Pictorial Compositions, 1350–1450* (London: Oxford University Press, 1971).

4

Although the date of Alberti's treatise is 1435, its influence on the theory of painting becomes marked only after its publication more than a century later, first in Latin in 1540 and then in the Italian translation by Lodovico Domenichi in 1547.

5

Matthew writes: "Then all the disciples deserted him and fled" (26:56), while Mark adds to this: "A certain young man was following him, wearing nothing but a linen cloth. They caught hold of him, but he left the linen cloth and ran off naked" (14:51).

6

As Sergio Benedetti has noted, the true light source in the *Betrayal* would be high on the left, beyond the depicted scene. The lantern's function, he writes, is "purely compositional." Benedetti, "Caravaggio's 'Taking of Christ,' a Masterpiece Rediscovered," *Burlington Magazine* 135, no. 1088 (November 1993): 738.

7

Roberto Longhi's identification of the witness in *The Betrayal of Christ* as one of Caravaggio's self-portraits (in "Un originale del Caravaggio a Rouen e il problema delle copie caravaggesche," *Paragone* 11 [January 1960]: 26–36) has generally been accepted. Another self-portrait, in which a witness, similarly placed within the composition, is once again observing a scene of violence, can be found in the late *Martyrdom of St. Ursula* (1610), a work discussed by Michael Fried in a lecture at Berkeley presented as part of a forthcoming book on Caravaggio. Fried's discussion continues his important and original work (especially in his studies of Courbet and Eakins) on instances of painters painting themselves into their pictures. We share this interest, although what we do with the cutting away of distinctions between subject and object seems to

us quite different from what Fried sets out to do when he takes up the same motif. Specifically, "relationality" in our discussion has very different ends and structure from "absorption" and "immersion" in Fried's work.

Maurizio Marini ingeniously proposes that we see in the witness of the *Betrayal* a Diogenes figure seeking Christian faith and redemption. Marini, "Caravaggio e il naturalismo internazionale," in *Storia dell'arte italiana*, part 2, *Dal Medioevo al Novecento*, ed. F. Zeri (Turin: G. Einaudi, 1981), 368.

8

Stanley William Hayter, "The Language of Kandinsky," *Magazine of Art* 38, no. 5 (May 1945): 177; quoted in Frank Stella, *Working Space*, The Charles Eliot Norton Lectures 1983–84 (Cambridge, Mass.: Harvard University Press, 1986), 104 and 116.

9

The ambiguity of the relation between being and history explains our refusal to capitalize being in this context; we are reluctant to invoke a metaphysical referent each time the word is used. The being that can't be visited is not an ontological essence or entity, but rather something like a principle of universal connectedness. A modern reflection on being must, in any case, be aware of itself not as an approximation of metaphysical truth, but rather as a moment in the history of how being has been thought. It seems to us that the ontology most congenial to an age of information is one that identifies being as relationality, as the principle of connectedness assumed by all technologies of transmission. Assumed, but also unnecessary: relational being (unlike Being as substance or essence) is by definition deployed being; to conceptualize it is already to give it visibility, to decapitalize it.

The notion of being as relational could be thought of as providing the philosophical logic supporting our earlier claims for art (in the sections on Beckett and Rothko in *Arts of Impoverishment* and in the section on Baudelaire in Bersani's *The Culture of Redemption* [Cambridge, Mass.: Harvard University Press, 1990]) as the concretizing and sensualizing of the metaphysical. The work of art is the site where the world reappears—*and* appears for the first time—as the "correspondences" (to use a Baudelairean term) that design, and perceptibly fail to design, the always mobile unity of phenomena. Finally, these reflections might be the point of departure for a new look at a question to which contemporary aesthetic theory has given a good deal of unilluminating attention: are there definable conditions under which the real qualifies as "art"?

10

Caravaggio is ambiguous about the cross as a spatial model. In Christian iconography, it is the absolutely centralizing form: to look at it is, properly, to be drawn to that point where the two

pieces of wood meet, the place of Christ's heart on his cross. The centripetal force of the cross can be diagrammatically figured by drawing in the virtual lines connecting its four extremities. This gives us the self-enclosed shape of a diamond, whose framed symmetry accentuates the visibility of the center. (The diamond could, however, be imagined differently. Its irradiating force obscures its center; it shines centrifugally, away from itself with an uncircumscribable shimmering.) But the cross's directionality is ambiguous. To move it, to decenter it ever so slightly (as we can see in the *Crucifixion of St. Peter*), is to initiate a propeller-like movement in which the center risks becoming invisible. (Walter Friedlaender notes the "constant implicit motion" of the wheel-like structure of this painting, "with its living spokes crossing each other diagonally," and that "might start to turn" [Friedlaender, *Caravaggio Studies*, 31]). In the *Martyrdom of St. Matthew*, two crosses are formed by two groups of figures. A crowded group to the left intensifies the centripetal effect of a crosslike structure, while in the more open grouping just to the right of the painting's center, both the fleeing boy and the angel bring a centrifugal force to that structure, as if the cross were in part rushing away from its center. *The Martyrdom of St. Matthew* communicates a double message about the movement to be associated with the cross. The more closed grouping to the left even includes diamond-shaped patterns on the vest of one of the figures, while the half-cross designed on the altar between Matthew and the angel seems almost to be set afloat, released from the centripetal pull of its missing elements.

11

Freud, *The Ego and the Id* (1923), in *The Complete Psychological Works*, 19:25–26.

7 BEAUTY'S LIGHT

1

Proust, *Remembrance of Things Past*, 1:201. Subsequent references to the Moncrief/Kilmartin translation will be given in the text.

2

Proust, *Du côté de chez Swann*, ed. Antoine Compagnon (Paris: Gallimard, 1987), 165–66.

3

Heidegger speaks of the "unconcealedness" of beings emerging in art. "The nature of art would then be this: the truth of beings setting itself to work" ("a happening of truth at work"). And: *"Art then is the becoming and happening of truth."* Heidegger, *Poetry, Language, Thought*, 36 and 71 (emphasis in original).

8 BEYOND—OR BEFORE?—SEX

1

Henry James, "Gustave Flaubert," in *Literary Criticism: French Writers, Other European Writers, the Prefaces to the New York Edition* (New York: Library of America, 1984), 326.

2

Ferdinand Brunetière, *Le Roman naturaliste* (Paris: Levy, 1883), 195.

3

Gustave Flaubert, *Madame Bovary*, ed. Leo Bersani, trans. Lowell Bair (New York: Bantam Books, 1959), 280.

4

Moir, *Caravaggio*, 92. Noting, as others have, that the youth "lacks a halo and the Baptist's traditional attributes, the cross and the scroll, and that a ram rather than a sheep is shown," Mina Gregori also finds that "the pose and the somewhat perplexing nudity of the youth . . . are difficult to reconcile with the ostensibly religious subject" (*The Age of Caravaggio*, 300). Creighton Gilbert has recently argued against the identification of the youth in this painting as St. John the Baptist. Gilbert renames the painting *Pastor friso* (Phrygian Shepherd), and he interprets the shepherd as a classical allusion to Paris. The painting is, in Gilbert's view, a critique of Annibale Caracci's *Paris and Mercury* in the Galleria Farnese in Rome. Gilbert, *Caravaggio and His Two Cardinals*, chapters 1–7.

Walter Friedlaender discusses Caravaggio's *St. John the Baptist with a Ram* as one of "two cases of persiflage directed at Michelangelo," the other being *Victorious Cupid* (see chapter 1, note 3 above). The Michelangelo work of which the St. John is a "travesty" is the ignudo above the Erythraean Sibyl on the Sistine Ceiling. Friedlaender, *Caravaggio Studies*, 89–91.

9 LOSING IT

1

In a more biographically oriented psychoanalytic interpretation, Hibbard also identifies Caravaggio with both "the beheaded Goliath" and "the youthful beheader." For him, "this identification would be the latent content of the painting as dream," and these "self-images accord, however superficially and roughly, with Caravaggio's own aggressive life." Hibbard, *Caravaggio*, 265–67.

2

Stella, *Working Space*, 103.

3

We frequently find in Caravaggio dark uninhabited spaces. In the relatively early *Calling of St. Matthew*, there is both the expanse of wall to the left of the window and, more strikingly, the even darker area below Christ's hand. The latter underlines the separation (which, as we have seen, is not merely physical) between the group seated at the table and Christ and Peter, both of whom are painted entirely within the shadowed area that occupies the lower right section of the painting. In the *Conversion of St. Paul* dark patches help to articulate the crowded space at the work's center, to emphasize the formal distinctness of all the juxtaposed limbs. The function of these dark spaces is more mysterious in Caravaggio's later work. The entire upper half of the *Resurrection of Lazarus* is a blank darkness, broken only by the massive but dim column to the left.

4

Quoted in Friedlaender, *Caravaggio Studies*, 247.

5

S. J. Freedberg speaks perceptively of the fusion of the optical and the tactile in Caravaggio, of "the sense in the mind of tactile experience." Freedberg, *Circa 1600,* 54.

6

Stella, *Working Space*, 103, 109, and 104.

7

Alfred Moir has emphasized the "frieze-like composition" of the painting. The figures "are removed from time and three-dimensional space that are indispensable to sequential action" (*Caravaggio*, 70). For us, the waiting presence of the old woman brings "sequential action" (or at least its possibility) back into the scene.

8

Leo Bersani and Ulysse Dutoit, *The Forms of Violence: Narrativity in Assyrian Art and Modern Culture* (New York: Schocken Books, 1985).

9

Others have pointed out the Leonardesque prototypes of this turning away on the part of Salome (for example, in Bernardino Luini's treatment of the same subject.)

10

In the *Martyrdom of St. Ursula*, the Hun shooting an arrow into the saint's chest occupies, like the executioner in *Salome*, half of the work's space. The four other figures are crowded together in the right half of the painting.

11

The often noted incisions Caravaggio made with a pointed tool on the fresh impasto of his paintings were a literal cutting into the space of his pictures. Keith Christiansen has written a fascinating essay on the function of these incisions (they position, at an early stage of the painter's work, the salient elements in the picture's overall design), as well as on their relation to Caravaggio's habit of painting directly from models, without preliminary designs. Christiansen, "Caravaggio and 'L'esempio davanti del naturale,'" *Art Bulletin* 68 (1986): 421–45.

Acknowledgments

We are grateful to Salvatore Geraci for his patient and expert preparation of the manuscript.

Photo credits:
Alinari/Art Resource, New York: figures 1.2, 3.3
Courtesy of the Louvre Museum, Paris: figure 5.2
Courtesy of the National Gallery of Ireland, Dublin: figure 6.1; plate 6
Nimatallah/Art Resource, New York: figures 2.3, 9.2, 9.3
Scala/Art Resource, New York: figures 1.1, 2.1, 2.2, 3.1, 3.2, 3.4, 5.1, 6.2, 6.3, 8.1, 9.1; plates 1, 2, 3, 4, 5, 7, 8

Index of Names